W9-CRS-105

Nevertheless, She Wore It

Nevertheless, She Wore It

50 Iconic Fashion Moments

Ann Shen

CHRONICLE BOOKS
SAN FRANCISCO

Text and illustrations copyright © 2020 by Ann Shen.

All rights reserved. No part of this book may be reproduced in any form without written permission from the publisher.

Library of Congress Cataloging-in-Publication Data

Names: Shen, Ann, author, illustrator.
Title: Nevertheless, she wore it : 50 feminist fashion moments /
 [text and illustrations by] Ann Shen.
Description: San Francisco : Chronicle Books, 2020. |
 Includes bibliographical references.
Identifiers: LCCN 2019046853 | ISBN 9781452183282 (hardcover)
Subjects: LCSH: Fashion—History—Juvenile literature. |
 Women's clothing—History—Juvenile literature.
Classification: LCC TT515 .S5375 2020 | DDC 746.9/209—dc23
 LC record available at https://lccn.loc.gov/2019046853

Manufactured in China.

Design by AJ Hansen.

10 9 8 7 6 5 4 3 2 1

Chronicle books and gifts are available at special quantity discounts to corporations, professional associations, literacy programs, and other organizations. For details and discount information, please contact our premiums department at corporatesales@chroniclebooks.com or at 1-800-759-0190.

Chronicle Books LLC
680 Second Street
San Francisco, CA 94107
www.chroniclebooks.com

*For everyone who finds power through fashion;
my dad, Tien; and my Aunt Pao, who always let me
permanently borrow whatever I liked from her closet.*

Contents

Introduction

Clothes can speak louder than words. This book details many fashion moments that became feminist statements. Since the Industrial Revolution and the democratization of fashion, people have been using personal style to express themselves—their identities, gender, and politics.

The clothes we wear are a glamour we cast into the world, showing how we want to present ourselves and be seen. It's the magic of creating our own image and communicating who we are at a glance. Dismissing fashion as feminine vanity or narcissism is inherently sexist. Women have historically co-opted personal style as a means of dissent and power. Each move has meant a new freedom. Bras meant no more disfiguring corsets, miniskirts liberated knees everywhere, and bikinis are for every body. The more women wear what they want to wear instead of what they're expected to wear, the more freedom and independence they gain—even if it's controversial at first. Often it takes rebels to change the status quo.

Whether we choose to stand out or stand together, caring about fashion is a way of reclaiming our power. Sometimes it's a movement, like the Suffragette tricolor stripe that supporters wore, and sometimes it's an individual style, like Ruth Bader Ginsburg's dissent collars. We have the choice of how we want to dress, and that allows us to reclaim our personal freedoms. Fashion helps us push the envelope and reframe what it means to be a woman. Even as styles change through the decades, these changes are led by especially bold and revolutionary fashion statements that may seem wildly avant-garde at first but then become downright iconic (see The Swan Dress, page 105; The Flapper Dress, page 48; The Bloomers, page 23). Wearing something bold takes courage, and that act of bravery helps give other people a new way to express themselves too. When Princess Diana wore her "Revenge Dress," she gave women a new way to see themselves after a divorce: confident and liberated

instead of shamed. When Marlene Dietrich slipped on a man's tuxedo, she showed the world that the masculine and feminine are in every person, that one doesn't have to be binary. These are some of the stories fashion can tell for us.

Expressing yourself as a woman is a political act. Our clothing and bodies have too often been subject to scrutiny by a patriarchal structure that works to hold us down. As long as women's bodies are governed by others, the personal will always be political. This book is an homage to those who claimed their own power through personal expression, a tool that's available to all of us as we get dressed every day. Through the stories that follow, I share the history of pants, the power of a lipstick, and the beauty of all the natural hair that has gotten us so far today. The genealogy of a style can help embolden you with a message and maybe, just maybe, help you find the courage and visual language to show up as the person you want to be. Fashion is freedom; personal style is currency. And you have an endless supply of it, baby.

Wear your heart on your sleeve,

Ann

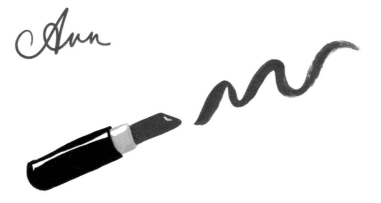

the Styles that Made a Statement

the Afro

In the 1960s, the Black Power movement was underway in the United States, and at the heart of it was a hairstyle that would come to epitomize the political and personal power struggles at play. The Afro hairstyle is worn by people with kinky, curly hair texture (also called "natural hair" in African-American communities). It features natural hair structure and volume, extending outward as it grows. The rise in popularity of the Afro was a form of reclaiming Blackness by the Black Western community, where white Eurocentric views of beauty dominated. Black men and women had been spending endless dollars and hours using creams, gels, and hot combs to straighten their hair—and gaining scorched scalps and burned ears in the process. It went beyond pursuing beauty standards; men and women weren't hired for jobs if they wore their hair natural because it was seen as "unprofessional." Focusing on the appearance of hair served as a shackle, holding down people deemed "other" by a white-centered idea of normal.

With the "Black is beautiful" movement that embraced Black beauty and norms, the community returned to their roots. Political activists like Angela Davis (professor and author) and Arnette Hubbard (the first female president of the National Bar Association) wore their Afros proudly in their work. Davis eventually came to resent being known for her famous Afro because she thought it overshadowed her political message—yet its iconic appearance remained linked to her political message. Glamorous stars like Diana Ross and Pam Grier rocked Afros. By the mid-'60s, college students followed suit, growing out Afros, much to the horror of their families, who feared for their safety and future careers. It wasn't just a generational thing, though: The Afro was for everyone looking to join the revolution. There were older men and women with natural hair, and there were college students who continued to straighten their hair to fit into the social structure they had worked so hard to rise

within. Fashion can still be a radical symbol as it becomes mainstream: Hairstyles have social, cultural, economic, and political impact.

The Afro raised a sense of pride in one's cultural identity as it came into fashion in the '70s and led to the natural hair movement of the late 1990s and on. Black hair care products became mainstream, and natural hair started appearing on screens and runways everywhere. Even so, there's still a long way to go. As recently as 2019 in New Jersey, a referee forced a Black high school wrestler to either cut off his dreadlocks or forfeit the match, claiming the hairstyle was unprofessional. The humiliating public event made national headlines and prompted California to become the first state to legally ban discrimination against natural hair. It also shows that standards for "professionalism" are still antiquated and deeply racist. Normalization of Black hair is important—as writer Bebe Moore Campbell noted in an article on Afros in the 1980s, "All hair looks better when heads are held high."

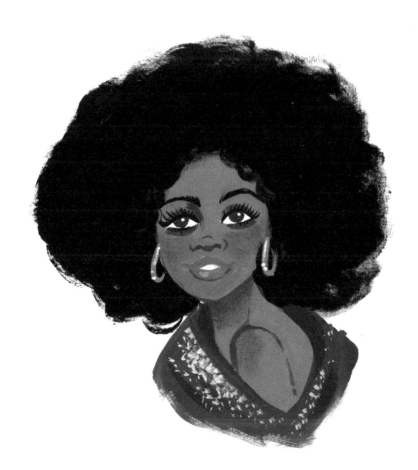

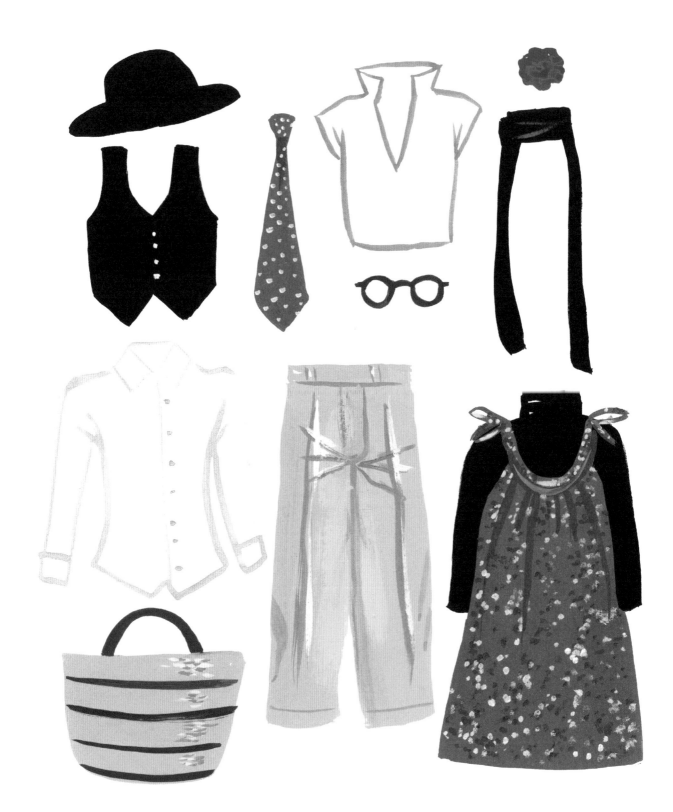

The Annie Hall

Menswear as womenswear reached its peak synergy in 1977's *Annie Hall*, in which actor Diane Keaton, playing the eponymous lead, ushered in the tomboy-next-door look. Once her style—white men's shirt with a black vest and tie, paired with loose khaki trousers, a black bowler hat, and large straw tote—hit the silver screen, women everywhere scrambled to their boyfriends', husbands', and fathers' closets for clothes to borrow.

This very style was opposed by the film's costume designer Ruth Morley, but Keaton was given free rein by director Woody Allen to pull from her own closet to inform the character of Annie Hall. It was Keaton's charm that pushed the look from masculine-meets-hobo to effortlessly feminine and cool. The actor claimed she was inspired by the chic women she saw on the streets of SoHo, and she borrowed the men's hat concept from fellow actor Aurore Clément after Clément wore a man's bolero hat on the set of *The Godfather: Part II*. Designer and friend Ralph Lauren also helped create the look that Keaton made her own; she borrowed many of his pieces to incorporate into Hall's wardrobe. Keaton's unique lens created a style that exuded tomboy confidence with a feminine sensibility.

Annie Hall's upturned polo collars and oversized blazers atop gigantic flowing skirts were in direct opposition to the hot pants and low-cut necklines of the disco 1970s. By the late part of this era, women were looking for a fresh way to say "la di da!" to society's expectations. Adapters of the Annie Hall look were pulling from menswear but presenting self-possessed femininity.

the Banana Skirt

In 1925, Josephine Baker set sail for France. She left behind years of struggling as a chorus girl on Broadway, two failed marriages, and a toxic relationship with her mother—all by the age of fifteen. Debuting in *La Revue Nègre* as a solo dancer, Baker became an internationally renowned performer and one of the most famous faces of the Jazz Age. And she did it all as a Black woman wearing an Eton crop hairstyle, strands of pearls, and a skirt of bejeweled bananas.

While her skirts were made of rubber, they were a play on the banana prop commonly used in vaudeville shows and dance halls. It was her clever way of subverting the colonial fantasy of a primitive and savage Africa that the French were madly in love with; never mind that she was from St. Louis, Missouri.

The origins of the banana skirt are hazy. Some credit the design of the skirt to Baker herself or to legendary surrealist Jean Cocteau. Other stories recount that the revue gave her the costume and she decided to make it her own. At the same time, her lover, artist Paul Colin, had created lithographs of her shows, and in two popular posters, he portrayed her in similar fashions. One featured a belt of palm leaves, which was a nod to her feather skirt costume. A second featured her in a banana skirt that echoed a ballerina's tutu, with Baker herself resplendent in lithe elegance.

Throughout her life and fame, Baker would continue to play with and subvert the ideas that were placed on her based on her race, gender, and sexuality. Just as quickly as she would slip on a banana skirt, she would perform in a male tuxedo. Her short, shiny Eton-cropped hair caused such fascination—when she first showed up in Paris, people often asked if she was a boy or a girl—that she licensed a pomade with her name that made her almost as much money as her performances. Her duality in playing up the image of a "savage" femme fatale that white audiences wanted to see while also being a sophisticated, elegant woman (often seen performing with

and walking her pet cheetah, Chiquita) bucked against society's expectations of a Black woman. By playing with her costumes, embellishing the bananas with rhinestones *and* spikes, Baker claimed her femininity and Blackness on her own terms. She commodified the French audience's fascination with exoticism and made herself a rich and powerful woman. As she once stated, "It is the intelligence of my body that I exploited, and that is what has turned me into an international star."

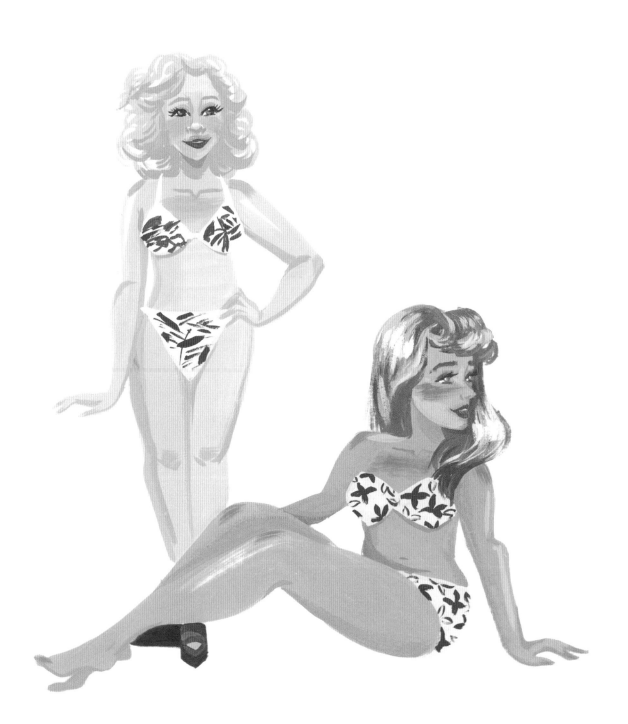

the Bikini

Controversial since its invention in 1946, the bikini is all about being comfortable in your own skin. As with many fashion trends, French women were early adopters of the bikini, with dancer Micheline Bernardini being the first to wear one and actor Brigitte Bardot the first to grab headlines in one during the Cannes Film Festival. In the United States, actors such as Marilyn Monroe, Rita Hayworth, and Ava Gardner made the bikini downright American.

Women's swimwear has a long and restrictive history. Invented in the mid-1800s, the first swimsuit for women was a floor-length wool dress, which women wore while being carried into the ocean inside a wooden hut by professional male "dippers." As coed beach bathing became more popular in the late 1800s, women's bathing gowns rose to ankle length while men wore sleeveless bodysuits that ended above the knee. The rise of the bathing suit hem correlates with the liberation of women and their bodies. In 1907, famed Australian swimmer Annette Kellermann, a.k.a. the "Diving Venus," was arrested for indecent exposure on a Boston beach. She dared to go without arm, leg, or neck coverage to practice competitive swimming. In 1952, Esther Williams portrayed Annette Kellermann in the film *Million Dollar Mermaid* in a halter swimsuit that ended at the top of her thighs. By this time, women had the vote, held jobs outside the home, and wore pants.

Named after the Bikini Atoll (a location that the United States used for nuclear bomb testing) because of its bombshell impact on fashion, the embrace of the bikini is the result of freedom from society's oppression of women's bodies. Every body is a bikini body, and the act of wearing a bikini is downright revolutionary, even today. It's a small but courageous way you can show up to love your body just as it is, and encourage others to embrace their bodies too.

the Black Beret

Tracing all the way back to the Bronze Age (3200–600 BC), the beret has existed almost as long as humans. Made of weather-resistant, durable, and easily accessible wool, the beret has been everything from a peasant's hat to a political statement. The beret's egalitarian roots have made it ubiquitous as the iconic headgear of many revolutionary groups. In the fourteenth through fifteenth centuries, felt disk hats were commonly worn by the lowest class of farmers and artists. In the 1800s, Spanish and French wars led to the beret becoming a symbol for soldiers. By the 1920s, the black beret had become a chic Parisian accessory for artists, poets, actors, singers, and other glamorous bohemian classes. During and after World War II, the beret became a military staple, especially for the US Army Special Forces, known as the Green Berets. Internationally, troops from every country were adopting berets in their military uniforms as well. In the 1960s, political leaders like Che Guevara and Fidel Castro made the beret a symbol of rebellion. And in the 1960s, the Black Panther Party, founded in Oakland, California, embraced the black beret as a symbol of power and revolution. The activist group wore black leather, natural hair, and black berets to celebrate their Blackness and symbolize being soldiers on the frontlines of political equality. In a country that has long suppressed Black individuals' rights and very existence, the Black Panthers emerged as a united front for breaking down the institution of racism.

The fight for Black equality continues today with the Black Lives Matter movement, and Beyoncé brought it to the front lines when she turned the most visible American pop culture event, the Super Bowl, into a political venue with a single performance. In February 2016, Beyoncé released her single "Formation" and its music video the Friday before her surprise guest performance at Super Bowl 50. Clad in a bandolier of bullets, she led her team of dancers dressed in black leather, with natural hair capped under black berets, in a performance of the song. An homage to the past, the

Black Panthers, the Black Lives Matter movement, and Malcolm X, the song brought inequality issues to the fore. In one performance, Beyoncé turned the sport field into a political stage. Six months later, San Francisco 49ers quarterback Colin Kaepernick sat in protest during the national anthem for the first time. A week after that, US women's soccer co-captain Megan Rapinoe knelt during the national anthem in solidarity. The visual image of a politically charged fashion statement and public performance can push equality into the public eye like nothing else. It's a pretty powerful statement that started with a simple little hat.

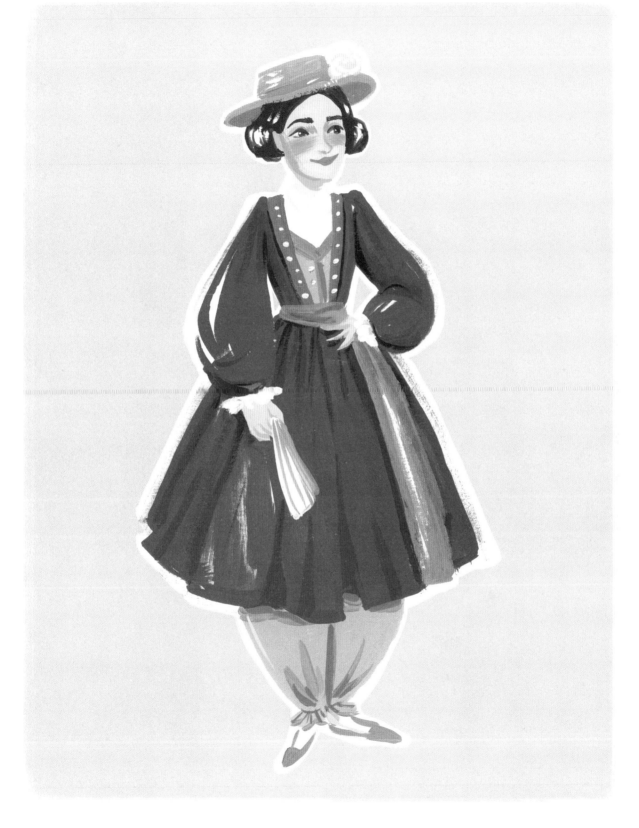

the Bloomers

Trousers were worn by Eastern and Middle Eastern women for centuries. The Turkish-inspired outfit of a skirt over loose pants—quickly dubbed the "bloomer suit" or "bloomers" for short—was first promoted in the United States in the 1850s by publisher Amelia Bloomer in *The Lily*, the first newspaper for women. Around that same time, the Victorian dress reform movement began. Women collectively wanted to shed disfiguring antiquated corsets for more comfortable modern fashions that were healthier for the body and would allow them to participate in athletic leisure activities such as swimming and bicycling. The bloomer suit arrived to fit the bill.

National Woman Suffrage Association cofounders and cousins Elizabeth Smith Miller and Elizabeth Cady Stanton brought Turkish women's dress to Seneca Falls, New York. It was there they met with Bloomer to share their newly adopted style. Initially reluctant to wear pants to the meeting, Miller recalled her cousin Stanton inspiring her with these words: "The question is no longer, how do you look, but woman, how do you feel?"

Soon after that fateful event, Bloomer promoted the outfit in *The Lily*, and hundreds of letters poured in asking for patterns. Women adopted bloomers as the official dress code of the feminist movement. Bloomer balls and picnics were held across the nation, with hundreds of women turning up in the new style of dress. Unfortunately, they were soon ridiculed by the press and harassed by the public at their own conventions. After three years of disparagement, the suffragettes decided that bloomers were distracting from their main cause and put them back on the shelf. They learned the power of fashion branding, and pivoted this new knowledge in a different direction (see The Tricolor Stripe, page 108).

23

The Bob

—

In 1915, ballroom dancer Irene Castle scandalized crowds and changed women's fashion forever when she cut off her long hair into a trendsetting bob.

Prior to Castle's hair foray, long hair on women was considered the peak of femininity. Gibson Girls, the epitome of American beauty, were known for their long tresses piled up in complex, voluminous styles. But Castle's short hair caught the fancy of independent and adventurous women.

Society was not as quick to embrace the bob. Young coeds who got bobs were threatened with expulsion from school. In 1920, F. Scott Fitzgerald even published a short story in the *Saturday Evening Post* entitled "Bernice Bobs Her Hair," a cautionary tale of a young woman who's tricked into cropping off all her hair and then gets rejected by her social circle and family. Yet despite an institutional push to quash the rise of the bob—and thus, by implication, the rise of women—women remained undeterred. When hairdressers flat out refused to cut bobs, the women turned to barbers, who obliged.

The tide turned when famous silent movie actor Louise Brooks appeared on-screen in 1920 with what would become her signature dark, blunt bob. Then the Sears catalog featured cropped hair. Finger waves, Marcel curls, shingle bobs, and the Eton crop (popularized by Josephine Baker) all came into fashion as new ways to style the bob. In 1925, the *Washington Post* published "Economic Effects of Bobbing," a story about how the popularity of the bob had increased the number of beauty shops in the country from 5,000 in 1920 to 21,000 in 1924 (not including barbershops, which still gave many bobs).

The popularity and scandal of short hair on women has persisted in waves throughout the decades. There's still something bold, flippant, and insouciant about a woman with cropped hair. Some fashion leaders have made it their signature, including *Vogue* editor-in-chief Anna Wintour and Japanese fashion designer Rei Kawakubo.

Eton Crop

Shingle

Boyish Bob

Cropped Curls

Flapper Bob

Clubbed Bob

Dutch Cut

Marcel Waves

Tapered Bob

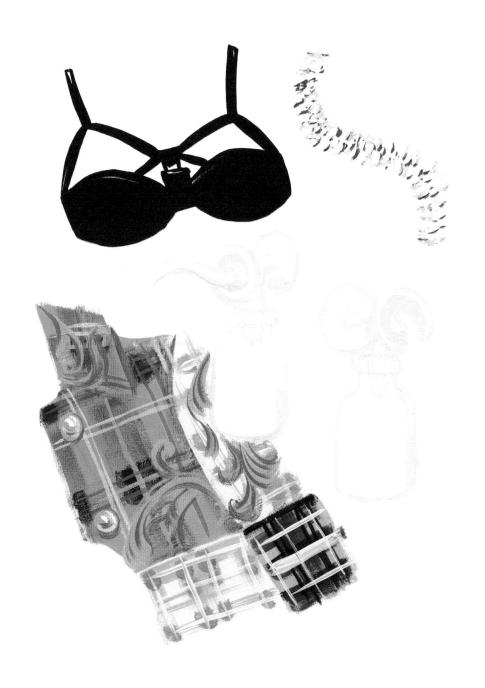

the Breast Pump

In 2018, actor Rachel McAdams took the cover off breastfeeding when she posed for a photo decked out in Versace, Bulgari diamonds, and a breast pump. She was working on a cover shoot for *Girls. Girls. Girls.* magazine with founder and photographer Claire Rothstein. McAdams was taking numerous breaks during work to pump, and the conversation between herself and Rothstein, something that could only be shared between two professional women, inspired the spontaneous shots. They incorporated the work McAdams was doing on her breaks into the shoot and collaboratively agreed to Rothstein later posting the shot to her Instagram account. The notoriously private McAdams didn't even announce her pregnancy or the birth of her son earlier that year, so allowing Rothstein to share such a personal part of her life in a confidently public way inspired many nursing mothers to feel seen and open up about their own experience.

Breastfeeding is such a normal part of our biology, and pumping can be a necessity for women returning to work, yet society expects women to hide themselves while feeding or providing food for their children. By glamorizing her breast pump, McAdams also normalized this very significant experience of being a mother. Being open and vulnerable about her experience helped to push away some of the shame and stigma around breastfeeding in public and also shifted the perspective on pumping and working motherhood. That's the power of fashion and photography: allowing other people to be and be seen as they are.

the Cape

The Met Gala in New York City is one of the most anticipated red carpets of the year. Each year's themes are eagerly interpreted by celebrities and the fashion elite alike, hoping for that worldwide headline. In 2018, the theme was *Heavenly Bodies: Fashion and the Catholic Imagination* and the headline from the event was grabbed by writer, producer, and actor Lena Waithe in a rainbow Carolina Herrera cape she cocreated with designer Wes Gordon. Waithe, fresh off becoming the first Black woman to win an Emmy award for comedy writing in the fall, had included reference to a cape in her acceptance speech: "The things that make us different, those are our superpowers— every day when you walk out the door and put on your imaginary cape and go out there and conquer the world because the world would not be as beautiful as it is if we weren't in it."

Waithe's very real cape incorporated black and brown stripes, which references the new pride flag adopted by the city of Philadelphia to elevate the visibility of non-white LGBTQIAP+ folks. Further bucking often binary-gendered red carpet fashion— men typically wear suits, women gowns—Waithe wore a chic black suit, sans tie, featuring two jeweled Verdura cross brooches that secured her cape on each shoulder. Her look was pure queer, Black, proud superhero—and her sartorial activism hit the mark. It showed so many people across the world that they could don their own capes and be the hero they were waiting for. When interviewed about her outfit, she said that she "felt like a gay goddess" and that she adhered to the theme because "the theme to me is *be yourself*. You were made in God's image, right?"

Capes are having a fashion moment on the red carpet, notably worn by trans women like Janet Mock and Laverne Cox. Queer fashion icon and actor Billy Porter also became a purveyor of the cape on the red carpet. The prevalence of the cape as a fashion choice on female and queer individuals pushes the notion of femininity as heroism. When you put on a cape, you can be your own hero. And you may just be one for others too.

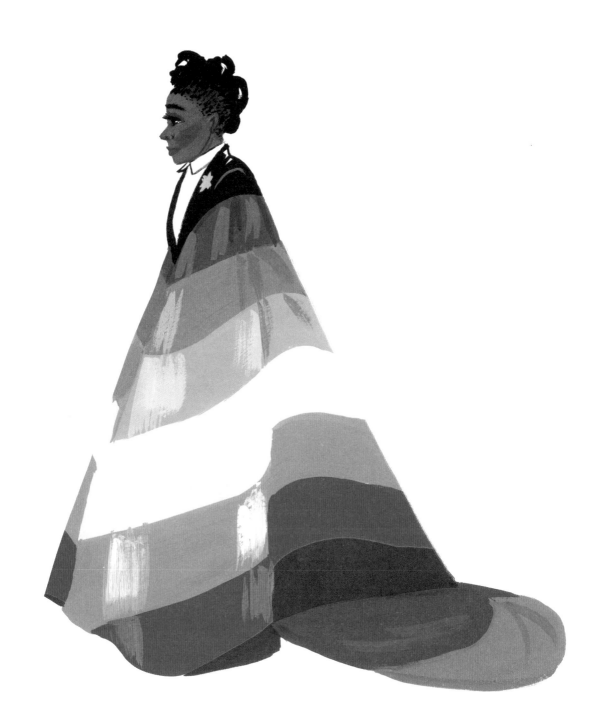

The Capris

Mary Tyler Moore started her trailblazing career by donning a pair of capri pants as housewife Laura Petrie on *The Dick Van Dyke Show*. With a legacy including her own eponymous show portraying a single, independent, thirty-something career girl who could turn the world on with her smile, who knew it'd be a pair of capris that would be her greatest career battle?

Moore opted to wear pants and ballet flats on *The Dick Van Dyke Show* because she stated that women didn't wear full-skirted floral dresses and heels to vacuum around the house. When the show creators finally went for it, the advertisers came in wringing their hands. They said that there was too much "cupping under," as Moore shared, meaning her butt was too cute and scandalous for television. Moore compromised by wearing looser pants in every other scene, slowly getting everyone acclimated to seeing her in pants.

The audience loved it—husbands had crushes on her and wives identified with her. It was as if Laura Petrie were the perfectly hair-flipped, doe-eyed Hollywood version of themselves. As Moore stated, she and all her friends wore capris at home, and women actually lived like this. The image of the regular housewife being elevated on-screen by such a charismatic and spunky actor was a breath of fresh air and, in a small way, normalized women in pants. Though she was in good company, with Lucille Ball and Vivian Vance also occasionally wearing pants on *I Love Lucy*, Moore and her act of sartorial defiance really helped women wear the pants so that they could just get to work.

the Cheongsam

The cheongsam (in Cantonese), also known as the *qipao* in Mandarin, was originally an ornate robe worn only by the Chinese emperor during the Qing dynasty. This high-collared, loose-fitting robe was soon adopted as traditional male attire across the upper class. Women's clothing during this era was thick, with elaborate separates—the higher class a woman, the more layers she had to wear while balancing on her tiny bound feet.

After the collapse of the Qing dynasty in 1912, the Republic of China rose and, with it, ideals of equality. The first wave of women's liberation hit China, specifically Shanghai, which was a port that saw many international citizens and female students pursuing higher education for the first time. These students established the New China Woman look by taking up the traditional menswear cheongsam and adapting it as their own, taking a physical step into equality by lightening up the weight of their wardrobe. At the time, the cheongsam had long bell sleeves and a straight loose A-line silhouette. It lost the fussy embroidery of the dynasty style, and adapted a simplified look that was popular with the new republic.

As the 1920s went on and Jazz Age influence started to ship in, the cheongsam adopted new tailoring techniques like darts, short sleeves, slits, and shortened hems that made it more form-fitting on women. Chinese pop culture started to feature glamorous women in calendars and cigarette ads wearing tight, beautiful cheongsams. All sorts of women started to wear cheongsams in their everyday lives, accessorized with stockings, T-strap pumps, cardigans, fur, red lipstick, and Marcel-waved hair.

Cheongsam wearers faced restrictions during the Cultural Revolution of the 1960s, when a plain, loose, two-piece outfit for men and women was worn virtually uniformly. This showed no differentiation for individuals in gender or class—stylish dress would be publicly reprimanded by Communist officials. Shanghai tailors and

many women fled the mainland to British-held Hong Kong, where they modernized the cheongsam to emphasize individualism in response to rebellion against Communist rules. This time zippers and snap fasteners were added for convenience; women were wearing cheongsams to work, in public spheres, for special events, and for daily life. Cheongsams went international in films like *The World of Suzie Wong* (1960) and *In the Mood for Love* (2000). The enduring power of this deeply Chinese symbol of fashion has roots in both royalty and rebels, which sums up the complex history of China itself.

the Cone Bra

In 1990, Madonna reclaimed the bra by wearing an exaggerated, Jean-Paul Gaultier–designed cone bra and corset for a performance of her power anthem "Express Yourself." The bra has long been an object of preoccupation and pain for women. First invented in 1914 by Mary Phelps Jacobs, the modern bra featured two cups made of handkerchiefs and ribbon to lift and separate and freed women from the bulky whale-boning and layers of a corset. Soon the male-dominated garment industry redesigned the bra with underwire, padding, and other feats of engineering to harness and fetishize breasts. For example, the Maidenform Chansonette bullet bra featured a signature spiral stitching over the cups to exaggerate curves instead of support them. "Sweater girls" in the 1950s wore them under tight knit tops to live up to the hourglass ideal of the era. Madonna blew up those notions altogether—and put her bra boldly on the outside for everyone to see.

Boundary-pushing Gaultier was the perfect designer for her collaboration. Gaultier was known for playing with the silhouette of the bust in his collections, exaggerating it to the point of camp. Fascinated with corsets that his grandmother told him about in his native France, Gaultier made his first conical bra corset for his teddy bear, Nana, as a child. In 1987, he debuted an orange crushed velvet dress that featured whimsically conical cups, a reference to a 1967 Yves Saint Laurent collection inspired by African Bambara art. When he met a young Madonna after her first single, "Holiday," debuted in 1983, a muse-friendship was born.

When Madonna embarked on her Blonde Ambition World Tour, she debuted her now-iconic blush-pink Jean-Paul Gaultier cone bra and corset for her "Express Yourself" set. A song about female empowerment and strength, "Express Yourself" became a pop anthem for women of the 1990s, with Madonna as an envelope-pushing leader. Love her or hate her, people couldn't stop talking about her.

Both her iconic fashion and her music would shape Madonna into a legend. When she launched her 2012 MDNA tour, she commissioned a reconstructed black leather cone bra corset that she wore over a white suit shirt and tie as a throwback to her iconic look.

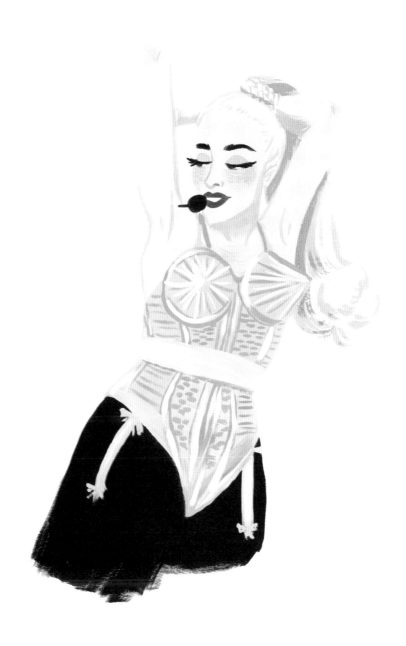

the Crop Top

There's nothing that rocks society like a woman's belly button. Crop tops came into popularity through their appearance on television; the first woman to bare her navel on television, Yvette Mimieux in *Dr. Kildare* in 1964, was only allowed past the censors because her character dies in a surfing accident. Soon, carefully monitored, navel-less midriffs entered homes weekly thanks to *Gilligan's Island* characters Mary Ann (Dawn Wells) and Ginger (Tina Louise), and the iconic Barbara Eden in *I Dream of Jeannie*. Belly buttons were still tactfully hidden until 1971, when Cher shared hers weekly on *The Sonny and Cher Comedy Hour*, despite getting in trouble for it repeatedly. Nevertheless, *People* magazine dubbed her the "Pioneer of the Belly Beautiful."

While Middle Eastern and Asian countries such as India have embraced crop tops as a wardrobe staple for ages (e.g., the short *choli* traditionally worn under a sari), the United States was first introduced to the crop top in 1893 during the Chicago World Fair. Belly dancers performed in a *bedlah*, a two-piece costume of a crop top and harem pants invented by Egyptian cabaret owner Badia Masabni, the "godmother of oriental dance." The bejeweled costumes and talented dancers brought in tons of attention, inspiration, and coins.

US designers adapted the crop top into women's fashion, often with a high collar and puff sleeves, and paired it with high-waisted skirts or pants to avoid showing any actual skin. During World War II, when raw material was rationed, girls took the opportunity to start wearing belly-baring tops during the summer. It emphasized the chic hourglass shape popular during this era, much to conservative society's chagrin. Even in New York City, a woman could be fined in 1945 for wearing her crop top with a pair of shorts, showing far too much midriff.

After Cher unleashed the belly button in the 1970s, all bets were off. The 1980s saw crop tops come in with ferocity as aerobics became extremely popular; two

dance films, *Flashdance* and *Dirty Dancing*, and Madonna's debut music video for "Lucky Star" shifted it from a youth trend to the cultural norm. In the late 1990s, pop stars like Britney Spears and Christina Aguilera took crop tops a step further with ultra-low-rise jeans, revealing more belly skin than ever before.

the Daisy Dukes

Made of a fabric steeped in masculine history—jeans were first invented by Levi Strauss in Gold Rush–era San Francisco for miners—denim cutoffs have become a decidedly punk and feminist statement. It's a perfect meeting of the liberated and controversial hot pants with the most democratic fabric ever invented.

First popularized in 1979 when Catherine Bach debuted as Daisy Duke on *The Dukes of Hazzard* wearing the shortest denim shorts ever to appear on national television, denim cutoffs have had many names: the namesake Daisy Dukes, jean shorts, jorts. Daisy Duke's shorts were so short that before production, the network demanded she wear nude pantyhose underneath to avoid scandalizing the audience and censors. Daisy Duke utilized her feminine power and denim shorts to get out of many tricky situations on the show, proving that she could ride with the best of them.

Cutoffs went punk in 1977 when both Patti Smith and Debbie Harry were photographed in ripped DIY denim hot pants. The particular brand of these two musicians— badass young women in New York—brought street credibility to denim shorts. They were as democratic and DIY as you could get. No one sold denim shorts; girls made their own. There were also male musicians and athletes who rocked denim shorts as a subversive statement. Why? Because denim shorts indicated a feminine confidence, a DIY attitude to ripping up the patriarchy and wearing and baring as much or as little leg as one liked (denim shorts would range from hot pants to Bermuda length).

In 2003, Beyoncé brought a resurgence of interest in the style when she rocked a pair of denim cutoffs in her iconic "Crazy in Love" solo music video debut. Nowadays a beloved staple of music festivals everywhere, women old and young don denim shorts as much for fashion as for function. The resistance against them is entirely misogynistic, given that it's a wardrobe staple of women everywhere.

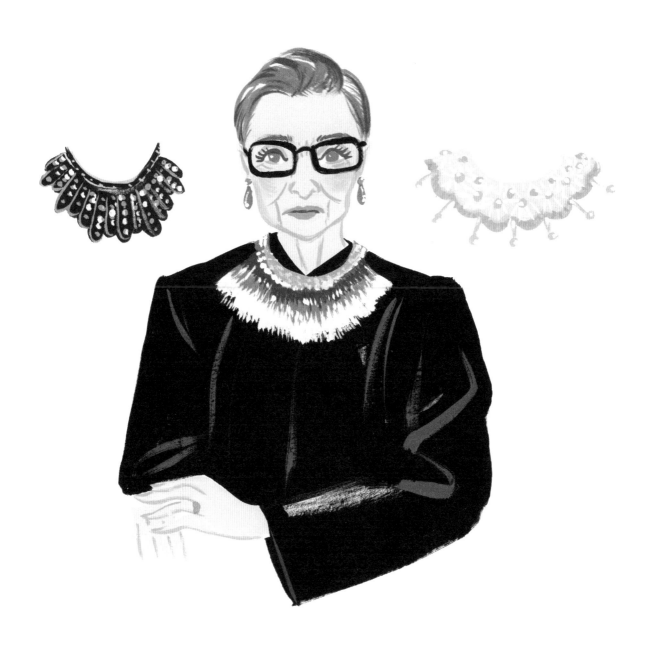

The Dissent Collar

Through her neckwear of choice, US Supreme Court Justice Ruth Bader Ginsburg makes a statement whether or not she's reading a court decision. The simple black judicial robe, often the same as ones available to college grads or choir singers, was designed to accommodate a man's shirt collar and tie. To add their own touch, justices Sandra Day O'Connor and Ginsburg decided to include something more feminine in their official ensembles: lacy jabots, beaded collars, and more.

Ginsburg went even further to have special-occasion collars that would also serve as a personal code. Her dissent collar was first featured in a 2014 interview with Katie Couric, in which Ginsburg gave the journalist a tour of her collar closet. Holding a beaded collar inspired by medieval armor, RBG stated that she wears the collar on days when she is dissenting from the majority opinion because this jabot simply "looks fitting for dissent." This infamous collar made an appearance in court the day after the forty-fifth US president was elected, even though there were no court decision announcements. Now that's some significant soft power only fashion can deliver.

Ginsburg also has a collar for announcing majority opinions: an embellished yellow and brown crocheted jabot that was a gift from her law clerks. For general court days, she often wears long white lace collars as a feminine take on traditional judge collars; one is featured in her 2000 official portrait. In many ways, the black judicial robe serves to separate the individual from the judicial intellect that serves the greater institution of the court. Trailblazers like Ginsburg and O'Connor, by adapting a costume that didn't account for female physicality, are reminders of how important it is for women to be seen in the public sphere. They represent half the population while up there, after all.

the Durag

A durag is a piece of fabric that's used to cover the hair and keep the wave pattern of a hairstyle in place. Headwraps and durags are both popularly worn in the Black community, an act of revolt through reclaiming accessories whose history is steeped in oppression and slavery.

In the late 1700s, the free African and African-American population grew in the then-Spanish colony of Louisiana. This freaked out King Charles III of Spain, who demanded the governor pass the Tignon Laws, which prohibited Creole women of color from dressing "excessively" on the streets of New Orleans and forced them to wear a tignon (a scarf or handkerchief, the precursor to a durag) over their hair to show they belonged to the slave class, even if they were free. White men were trying to suppress Black women's beauty and power, afraid of interracial relationships and their perceived threat to the social order. In response, Black women did indeed cover their hair but continued to deck it out in jewels and feathers, co-opting the wrapped style. After the United States purchased Louisiana in 1803, the law was struck down, but women continued to resist white racism through their hair accessories.

At the end of the nineteenth century, Black women started to straighten their hair into submission to fit into white Eurocentric ideas of beauty and gain acceptance through compliance. The acceptance meant more opportunities in a white-dominant

economic power structure, but at the cost of Black women's ability to free their hair, not to mention harsh and time-intensive styling regimens. However, the Black Pride movement of the 1960s and 1970s ushered in a new wave of using the durag (for men) and headwraps (for women) as resistance fashion. Nina Simone often performed wearing a head scarf resembling the tignon of New Orleans women. In 1979, the brand So Many Waves created a "tie down," a scarf cap that held down brushed-out hair so the wave pattern would set. The scarf, often made of silk or polyester, also kept frizz at bay. It was usually worn in private spaces, but soon became a public resistance accessory.

In the 1990s, the durag became a staple of male rappers like Jay-Z, Nelly, and 50 Cent. Once Black people started to own the style publicly, mainstream society labeled it as crude and associated it with criminal behavior. In the 2000s, in a targeted, racist move, both the NFL and NBA (both sports where Black men are a majority of players but underrepresented in team ownership) banned durags and bandanas. Black women were also penalized for wearing headwraps in work spaces, again being deemed "unprofessional."

Intertwining the history of the head wrap and co-opting the traditionally masculine durag, now wearing a durag is also an act of Black female rebellion. Rapper Eve started the ball rolling in the 2000s when she wore durags while attending fashion shows. Rihanna wore a Swarovski crystal-encrusted durag to collect her CFDA Fashion Icon Award in 2014. Two years later, she performed at the MTV Video Music Awards decked out in a durag, and in 2017, she outfitted her models in durags for her Fenty x Puma runway show. Durags became a symbol of leaning into authentic Black excellence. In 2018, Solange Knowles elevated the durag to celestial status when she wore a black one underneath a golden braided halo to the Met Gala, whose theme that year was *Heavenly Bodies: Fashion and the Catholic Imagination*. The extra-long cape on her durag was bedazzled with "MY GOD WEARS A DURAG." Knowles's outfit was a piece of resistance performance, embodying a symbol of Black divinity in a space where Black bodies have been systematically removed and erased.

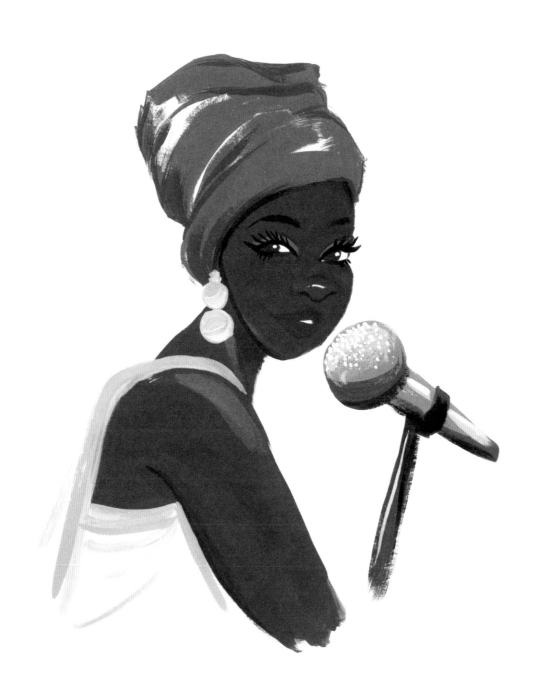

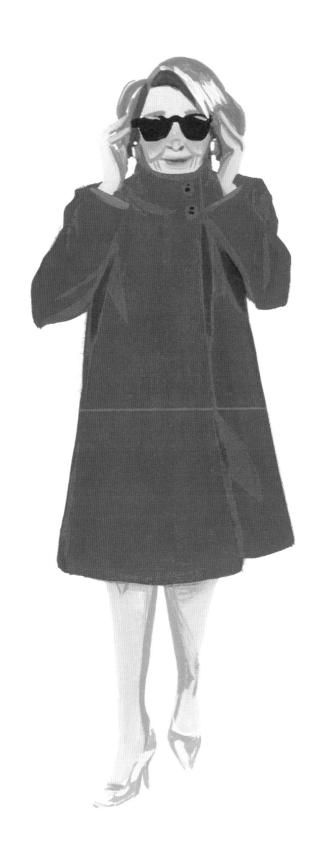

the Fire Coat

When Speaker of the House Nancy Pelosi first met with the forty-fifth US president after the 2018 midterm elections, in which the Democrats seized control of the House, one could imagine that sparks would fly. Less expected was that the sparkler would be one fire-red coat from Pelosi's closet.

The televised conversation between Pelosi, Senate Minority Leader Chuck Schumer, the president, and his vice president was akin to a reality show reunion episode. But during the tense discussion, Pelosi didn't budge.

After the combative fifteen-minute showdown, Pelosi slung on her high-collared coat like a cape, popped on her dark sunglasses, and stepped out gracefully in her high heels. Proving, once again, that women can do everything men can—plus they can do it backward and in heels. The coat set the media and the internet ablaze, with two Twitter accounts devoted to the coat popping up overnight, and Academy Award–winning director Barry Jenkins comparing Pelosi's moment to being "shown in full, rhymed with Ms. Bassett in *Waiting to Exhale*. What she wore was so declarative it could not be erased." Jenkins was referring to a scene in the film *Waiting to Exhale* where Angela Bassett's character torches her cheating husband's car and walks away in a glamorous white coat. *New York Times* fashion director Vanessa Friedman identified it as a design that Pelosi also wore during President Barack Obama's second inauguration. Pelosi's statement in wearing that same coat was not unnoticed during this particularly precedent-setting meeting as she regained her seat as Speaker of the House. As Jenkins tweeted, "This is diplomacy in motion, soft power wielded like a machete through the diligent, decisive act of dressing. They've never been JUST clothes."

the Flapper Dress

When the Nineteenth Amendment gave women the right to vote in 1920 (although state governments continued to keep women of color from exercising that right for decades), a major feminist wave washed over the US, and it was wearing a flapper dress. For the first time, white women were attending college, joining the workforce, and driving cars. World War I had ended; many men had not come back. Suddenly, society's structure had changed. Young women's access to their own income and mobility brought about the desire for autonomy and personal fulfillment; and, with that, women loosened their mothers' Victorian corsets and chopped off their long locks. Prototypical flappers—such as writers Zelda Fitzgerald and Ellen Welles Page—Charleston'ed into the public eye. Actors including Clara Bow, Louise Brooks, and Joan Crawford portrayed liberated and adventurous flappers in films of the era, which made the style even more popular among progressive young women.

An androgynous, rectangular silhouette was in vogue, and undergarments shifted to accommodate. Instead of deforming Gibson Girl corsets, flappers got step-ins and side-lacers that were looser and de-emphasized the female figure's natural curves. Knee-length, drop-waisted dresses with angular collars and straight lines were imported from Europe, where flappers had already been trending in France. European designers including Jean Patou, Elsa Schiaparelli, Coco Chanel, Madeleine Vionnet, and Jeanne Lanvin all made contributions to signature aspects of the flapper dress: raising hemlines, adding knitwear, inventing the bias cut, and incorporating delicate beadings and trim. (Fringe was an invention of 1950s Hollywood films when elastic blend fringe was cheaper and easier to attain.)

Soon flapper styles became mass market, appearing in the Sears catalog. Accessorized often with a cloche hat, bob haircut, rolled socks, and red cupid-bow lips, the flapper dress became symbolic of a time when women started to shed the trappings of the patriarchy and achieve independence. Rebellions start personally, in the closet, and can become so powerful they change a nation.

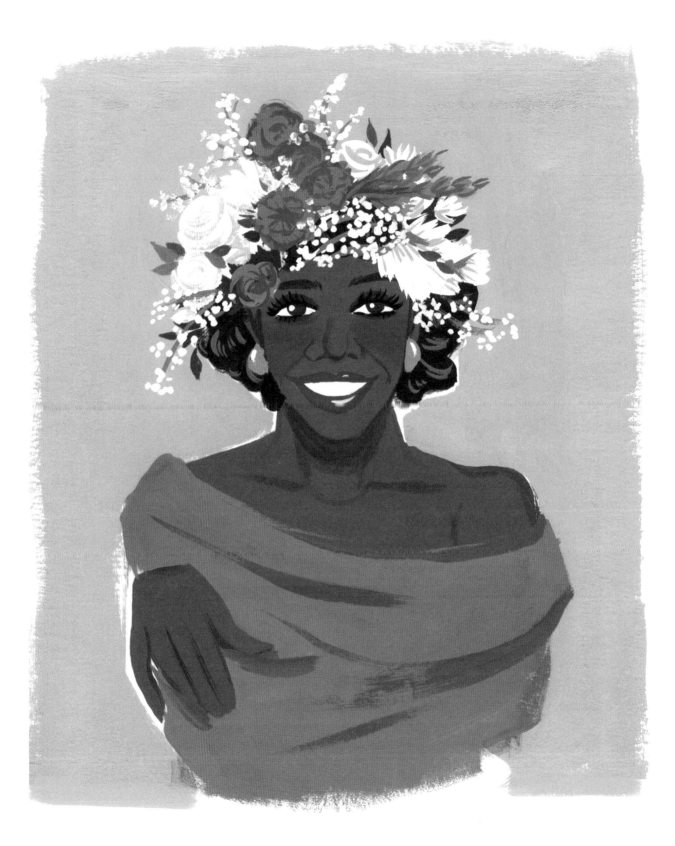

The Flower Crown

Flower crowns didn't start with music festivals; they date all the way back to the ancient Greeks and Romans. Since antiquity, the circular wreath of leaves and/or flowers has been a symbol of glory and power. Crowns of myrtle, olive, or bay laurel leaves were often awarded for athletic, military, or artistic achievements; to this day the laurel wreath remains an emblem of the Olympic Games. Gods and goddesses were often depicted ringed with a floral or leaf crown. Grass crowns made from weeds and wildflowers gathered at a site of victory were awarded to winning commanders as the highest military honor.

Later, floral crowns evolved into symbols of femininity and connection with nature. They were worn during midsummer traditions in northern European countries such as Sweden and Latvia, where they were believed to prevent disasters and diseases. In the Ukraine, girls wore wreaths of periwinkle and myrtle when they reached a marriageable age. In China, brides wore orange-blossom flower crowns symbolizing fertility, because the orange tree blossoms and bears fruit at the same time. In the United Kingdom, floral crowns reached a fever pitch when Queen Victoria adopted the orange-blossom crown tradition for her own wedding in 1840. Victorians had a love for floral communication, imbuing each flower with its own meaning and creating coded arrangements. The obsession picked up again in the 1960s, during the flower-child era, when people

adorned themselves with wildflower crowns to feel more in touch with nature. Actor Elizabeth Taylor wore a crown of flowers for her first wedding to Richard Burton in 1964.

In the 1970s, African-American trans and LGBTQIAP+ rights activist Marsha P. Johnson made flower crowns her signature. Moving to New York City right after high school and struggling between homelessness and sex work to support herself, Johnson fashioned herself into a drag queen and became a fixture in the vibrant queer community of Greenwich Village. Often adorned with homemade flower crowns, Johnson assembled her wardrobe from salvaged materials including red high heels, sparkling robes, colorful costume jewelry, and bright wigs. Her warm charisma and joy, along with her status as a leading figure in the drag community, made her a "drag mother" to many people. Johnson called herself a *drag queen* and *transvestite* (*transgender* hadn't entered the lexicon yet), and established the Street Transvestite (now Transgender) Action Revolutionaries (STAR) group with her friend Sylvia Rivera. STAR fought discrimination against trans folks and ran STAR House, a safe shelter for homeless transgender and queer youth of color. Johnson was on the front lines of the 1969 Stonewall uprising, where members of New York's gay community rioted against police discrimination. In addition to her activism, Johnson modeled for Andy Warhol and became a successful performer, touring the world with the performance troupe Hot Peaches.

By writing herself into the history of the floral crown, Johnson fashioned her own image of beauty, joy, and autonomy. The flower crown carries with it the symbol of power, dignity, and courage—of achievement over obstacles and embracing the divine feminine. So, despite how much people want to dismiss floral crowns, now ubiquitous at music festivals and in social media filters, it's undeniable that the glory attributed to them is part of our nature and history.

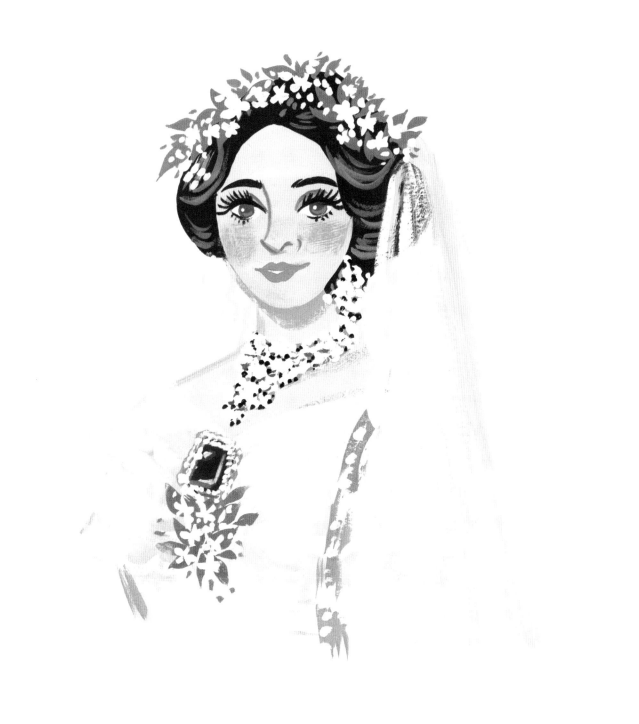

the gaulle

French queen Marie-Antoinette was known for her fashion sense, which both delighted and disgusted aristocrats and the public. Her most scandalous fashion moment came when painter Élisabeth Vigée Le Brun unveiled Marie-Antoinette's portrait *La Reine en gaulle* at the Salon du Louvre in 1783. Marie Antoinette was portrayed in a loose white muslin chemise (*a gaulle*) that she commonly wore on her private Petit Trianon estate. Made of soft linen ruffled layers, gathered puff sleeves, and tied with a waist sash, the gaulle was equivalent to underwear. Aristocratic women wore gaulles over their corsets and under their finer silk gowns, but to wear the gaulle alone, much less portrayed in a royal portrait, was downright shameful. The fact that she was holding roses of her native Austria and wearing a peasant's straw hat enraged the French even more. She was accused of looking like a serving maid and an independent woman, not representing the symbols of the French monarchy. The French silk textile producers also blamed her for killing their industry and advocating Anglophilia since gaulles were made of imported British linen. This was considered especially atrocious since the French were at war with Britain at the time, fighting in support of the US revolution against colonial rule. Already a loathed outsider snarkily nicknamed *L'Austrichienne*, Marie-Antoinette was accused of rejecting the French completely while spending all their money remodeling Petit Trianon and holding exclusive parties they weren't invited to.

The public fury was so outrageous that Vigée Le Brun quickly replaced the painting in the Salon with another, *La Reine à la rose*, which portrayed the queen in a traditional French silk gown and rich pearls. Sick of never pleasing the French, Marie Antoinette persisted in flouting the public opinion and wearing her gaulles and straw hats—even into Versailles, where she now refused to dress more traditionally. She gifted foreign queens and duchesses with gaulles of their own, and even

named her daughter Mousseline (which translates to muslin). Despite French aris-
tocrats' disdain, the greater French and British public embraced Marie-Antoinette's
forward-thinking style (after all, gaulles were more comfortable than traditional
heavy gowns), and muslin chemise dresses became a popular style in the 1790s. They
also served as a precursor to the lighter dresses of the nineteenth century and slip
dresses of the late twentieth century.

the Hot Pants

Following the miniskirts of the 1960s, hot pants reached the peak of their fame in 1971 with dozens of songs dedicated to the microscopic shorts. With an inseam no longer than two inches, hot pants are short shorts that came from fabric innovations that saw polyester and stretch fabrics become everyday wear. Interestingly, hot pants reached their tipping point in the winter of 1971, when cool British girls wore them with leggings, thigh-high boots, and a long coat.

Though shorts had been worn as early as the 1930s, most were for sports and leisure. Inventors of the miniskirt, purveyors of the mod look, and international rivals André Courrèges and Mary Quant once again changed fashion history with their innovations on the modern hot pants. They were made in non-activewear fabrics, like velvet, silk, crocheted yarn, fur, leather, and suede, and seen everywhere from the dance floor to the skies. Southwest Airlines flight attendants wore a tangerine uniform of short shorts and knee-high boots. Hot pants fever permeated popular culture as they were worn by adventurous and conservative fashion icons alike. Women got married in bridal hot pants with an accompanying skirt. Jacqueline Kennedy Onassis wore a pair while yachting. Iconic actors Elizabeth Taylor, Raquel Welch, and Jane Fonda all wore hot pants. They weren't even exclusive to women—megastar musicians like David Bowie, Sammy Davis Jr., and Liberace also rocked hot pants.

The style was celebrated by many as part of the women's liberation movement: Hot pants furthered the notion that women could wear whatever they wanted to. They were symbolic of the sexual revolution of the '60s and women's newfound power in the public sphere—though there were, of course, detractors who claimed that they were only playing into the male gaze. Hot pants live on, though—now popularly referred to as "booty shorts," this fashion item continues as a part of wardrobes everywhere. Hot pants can still be found on college campuses, dance floors, and stages across the world—on both women and men. Long live the legs!

the jeans

When denim jeans were first patented by Levi Strauss and Jacob Davis in 1873, they were made for gold miners on the California coast. In the 1920s, Western cowboys adopted jeans, giving the clothing a romantic rugged appeal, even entering the pages of 1930s *Vogue*. Female outlaws like the infamous Pearl Hart wore jeans as an act of rebellion around the turn of the twentieth century. Hart was arrested in Arizona wearing a button-up shirt, denim "waist overalls" (the original term for jeans) held up by thick suspenders, tall leather boots, and her gun. She was forced to change into traditional female dress for her mug shot.

As more women entered the workforce during World War I and World War II, denim became a necessary part of their wardrobe. Initially, women tried to make denim jeans acceptable by calling them "divided skirts," as worn by pioneer women in the West for riding horses and running ranches. Then, after the First World War, Levi's invented "freedom-alls" (denim overalls) for women—the most famous pair appearing on Rosie the Riveter in a 1943 World War II campaign. The character, based on real-life riveter Naomi Parker Fraley, was part of a campaign to get women into the workforce. Women's access to denim then became a symbol of power and national pride.

In the 1950s, jeans became a mark of youth and rebellion. Bad boys like James Dean in *Rebel Without a Cause* and Elvis Presley made jeans carefree and dangerous. Marilyn Monroe made jeans downright feminine and sexy in *The Misfits*. In the 1960s, jeans became part of hippie culture, with new bell bottom cuts and DIY styles—embellished with patches and hand paintings. The versatility of jeans—and their innovative comfort features that developed later, including stretch material, zipper fly fronts, and a variety of cuts—became a symbol for independence, freedom, and youth culture. In the liberation of the 1970s, girls cut off the legs of their jeans to embrace the Daisy Duke (see The Daisy Dukes, page 39). By 1988, Anna Wintour had put jeans on her first

US *Vogue* cover and denim became accepted into the lexicon of high fashion, and not just for laborers and young punks. In the '90s, denim went designer, and labels like 7 For All Mankind and Paper Denim & Cloth started selling jeans for over $200 a pair.

Nowadays, jeans can be found anywhere from the playground to the boardroom to the red carpet (Britney Spears and Justin Timberlake's 2001 American Music Awards matching denim looks come to mind). They still have the iconoclastic ability to be a tool of rebellion: In 1999 enraged Italian women organized Denim Day in response to the ruling in a rape case. The case was dismissed when the court ruled that the defendant's jeans were so tight that she must have helped him get them off her body—and therefore it must have been a consensual encounter. Annually on April 24, people around the globe wear jeans to support survivors and educate others about all forms of sexual violence. For a humble item of utility clothing, jeans sure can do a lot.

the jumpsuit

Jumpsuits started out as extremely humble work garments for manual laborers. Originally called "boilersuits" or "coveralls," the loose-fitting, working class garment carried connotations of gender equality and class neutrality. In 1919, an Italian artist named Thayaht created a simple cotton jumpsuit he named the TuTa, intended to be an anti-bourgeois statement for the working class. However, everyday people had very little interest in the TuTa, and the Florentine upper class became his audience (much to his horror).

In the late 1970s, the jumpsuit would finally make a leap into fashion when stars like Diana Ross and Cher wore them. Though icons from eras past, like Gypsy Rose Lee and Nina Simone, also wore netted jumpsuits over very little else, the '70s brought in disco and glamour that felt achievable for everyone. Ross, a purveyor of over-the-top style, donned many a sequined jumpsuit (alongside numerous wigs, feathered coats, and long sparkling gowns). Ross and Cher both loved the designer Bob Mackie, who specialized in showmanship. Ross wore two separate jumpsuits at her 1983 landmark performance in Central Park, singing through a torrential storm for 450,000 people. As the rain poured down, Ross—who was the first female Black performer to head-line such a show—persisted. She opened in a sparkling orange jumpsuit and rotated through multiple outfit changes, including a now-iconic shimmering purple jump-suit. The embrace of the jumpsuit came alongside new liberations for women; it represented the fact that you could have equal rights, power, and money and still be a glamorous woman. You didn't have to present in a masculine-gendered way to have access to the same rights or voice. Ross made a statement with that moment and set a tone for all women to come.

The Lobster Dress

Brainchild of surrealists Salvador Dalí and Elsa Schiaparelli and worn by one of the world's most notorious women (American socialite–turned–Duchess of Windsor Wallis Simpson), the Lobster Dress lives on in infamy. Fashion designer Schiaparelli was already well known by the 1930s as a surrealist artist. She was an innovator of women's fashion: She designed the first bathing suit with a built-in bra, created the wrap dress prototype, paired jackets with evening gowns, used her signature hot "shocking" pink throughout her collections, and modeled a perfume bottle on Mae West's curves (the perfume was, naturally, named Shocking).

Schiaparelli often collaborated with her surrealist artist friends on her fashions. Jean Cocteau drew a face on the back of one gown she designed. She created a shoe hat that was inspired by a photo of Dalí wearing a woman's shoes on his head. Then they paired up to design the Lobster Dress. Dalí had already used lobsters in his artwork, often as a symbol for sexuality—including the famous *Lobster Telephone* mixed-media sculpture. The Lobster Dress debuted as part of Schiaparelli's 1937 Summer/Fall collection, and was a long, sheer, white silk evening gown with a crimson waistband and a large lobster with sprigs of parsley on the skirt. The lobster art was painted by Dalí and translated onto the fabric by leading silk designer Sache. Suggestively placed between the legs of the wearer, the large crimson crustacean commanded a lot of attention and sexual connotations on an otherwise virginal white bridal gown. It was rumored that Dalí had wanted to paint with real mayonnaise on the dress too, but Schiaparelli drew the line there.

And then the dress was worn by one of the most controversial women of the time, Wallis Simpson, who was set to marry the Duke of Windsor after he abdicated his claim to the throne to be with her. In an effort to soften her image, Simpson decided to do an engagement photo shoot with Cecil Beaton for the pages of

Vogue. She chose the elegant Lobster Dress, which only incited more ire when the romantic and (honestly, still) inspirational fashion shoot was given an eight-page spread in *Vogue*. The dress was decidedly charged with erotic flippancy and gave the British public even more reason to hate Wallis—the twice-divorced American who stole their king. This shows the power of innovation and sexual empowerment in a woman—and the impact art and fashion can have.

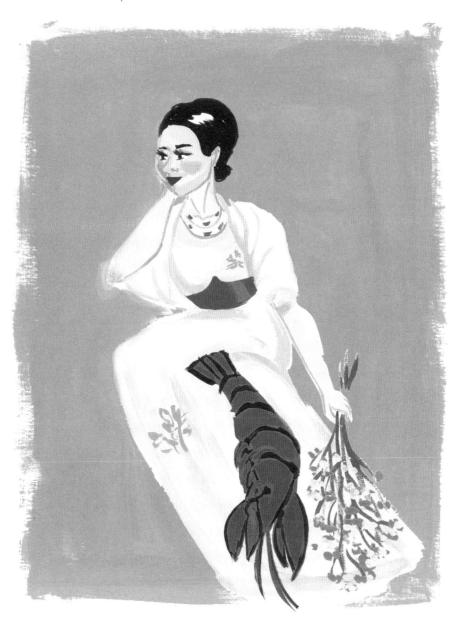

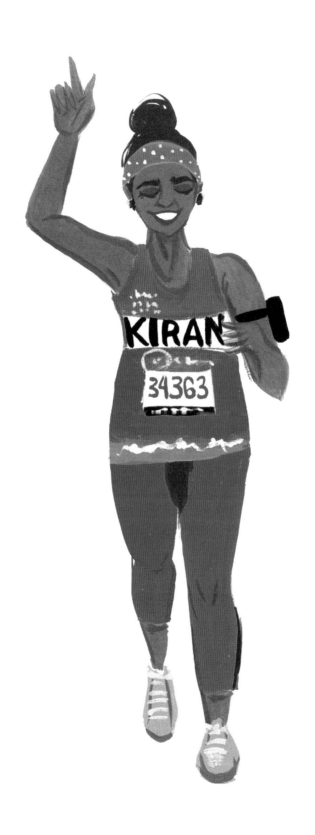

the Marathoner

Although Kiran Gandhi trained for a year to prepare for the 2015 London Marathon, she didn't plan for what she'd do if she were on her period for the event. So when it arrived right before her run, she decided to opt for comfort in pursuing this physical goal and free-bleed while running the 26.2 miles. Her decision prompted both loud praise and criticism—and highlighted the pains women go to to hide a natural, biological occurrence that 50 percent of the population face monthly. The Harvard MBA grad and frequent drummer for M.I.A. stated that her choice was to "raise awareness about women around the world who have no access to feminine products and to encourage women not to be ashamed of their periods." "Free the Period" was born—a movement bringing menstruation out of the dark and into public conversation.

The reaction to Gandhi's run, which included calling her "unladylike," "unhygienic," and "disgusting," exemplified the problem society has with women's bodies. As Gandhi stated, "Culture is happy to speak about and objectify the parts of the body that can be sexually consumed by others. But the moment we talk about something that is not for the enjoyment of others, like a period, everyone becomes deeply uncomfortable." Women and girls are in the dark and withdraw from society monthly because of the way menstruation is addressed (or often, not addressed at all)—as something shameful to be hidden. Sixty-six percent of girls in Southeast Asia don't even know about menstruation until they start it. The stigma only serves to hold down women—especially those in poverty who do not have access to feminine products. Legislators, companies, and athletes have been bringing this to light—very possibly all sparked by Gandhi's courageous 2015 run while free-bleeding. Her triumphant finish line photos with her friends and family, having bled through her running pants, were the shots seen around the world.

the Meat Dress

When Lady Gaga showed up to the 2010 MTV Video Music Awards to collect eight awards, she wore a now-infamous dress made of raw flank steak and prime rib cuts by designer Franc Fernandez. She had to be hand-sewn into the garment and gave a statement that "if we don't stand up for what we believe in and we don't fight for our rights, pretty soon we're going to have as much rights as the meat on our bones."

While the Meat Dress stirred controversy (and was named the top look of 2010 by *Time*), this wasn't the first time Gaga adorned herself in meat. She wore a raw meat bikini on the September cover of *Vogue Hommes Japan* just before the award show. Garnering media attention for her style is one of Gaga's signature moves, a tool we can all use. A couple days after the MTV VMAs, Lady Gaga gave an impassioned speech highlighting the dress as her statement against the US military's "Don't Ask, Don't Tell" policy, which prohibited any homosexual or bisexual individual from disclosing their sexual orientation or mentioning anything about their sexuality while serving in the US Armed Forces. Anyone openly queer was discharged from the military or banned from enlisting in the first place.

Lady Gaga arrived in Maine, the battleground state in which two US senators were still on the fence about repealing the policy, to deliver her "Prime Rib of America" speech. She likened equality to being the best cut of meat available, the prime rib, arguing that US citizens don't all get fair access to it—even if they're laying down their lives for it. Gaga's efforts brought a major influx of attention to the issue, with the Service Members Legal Defense Network (which was running a call-your-representatives campaign) reporting a record spike in visits to its website. In December 2010, the Senate voted to repeal "Don't Ask, Don't Tell." The Meat Dress remains in Lady Gaga's possession, though it was preserved by a taxidermist and more closely resembles jerky now. It's often loaned out for museum exhibitions. Now that's the power of raw publicity.

the Miniskirt

68

"A miniskirt is a way of rebelling."
–Mary Quant, New York Daily News

Miniskirts go as far back as 5000 BC, with depictions of young girls in short skirts found on frescos in Egypt and figurines in Europe. But it was in the 1960s that miniskirts rose to power as a feminist symbol of liberation and rebellion against the postwar 1950s.

British fashion designer and boutique owner Mary Quant led the charge. While the creation of above-the-knee dresses can be attributed to several designers around this time, Quant credits "the girls on the street" for inventing the skirt. People didn't want to dress like their parents anymore—and that meant miniskirts! Bazaar, a Chelsea boutique that Quant cofounded with her husband, was the ultimate hangout for stylish young women in the 1960s. Quant designed a skirt based on one she had seen on a tap dancer, and her clientele kept asking her to raise the hem. Quant named it after her favorite car, the Mini Cooper, because both embodied a flirty, fun, exuberant spirit.

While hemlines rose in the 1920s for flappers during the first wave of feminism, the 1960s really liberated knees everywhere. It was an era where women had newfound autonomy over their bodies and destinies, especially once the birth control pill came into the picture, and they flaunted it by showing a lot of leg. Models like Twiggy, who embodied the spirit of the 1960s with her pixie haircut, straight silhouette, and legs for miles, made the miniskirt famous. Across the world, another gamine British model, Jean Shrimpton, caused a major stir at the Melbourne Cup Carnival in Australia when she showed up wearing a miniskirt with no stockings. Miniskirts were brought into homes across the United States when Goldie Hawn and her minis regularly appeared on the television show *Laugh-In* and when Jackie Kennedy opted for a white Valentino minidress for her wedding to Aristotle Onassis. They are now associated with youth, beauty, and liberation.

Miniskirts have endured as a symbol of female freedom over the decades, donned by leading intellectual feminists like Gloria Steinem and punk stars like Debbie Harry in the 1970s, as a lace wedding dress by Madonna in the 1980s, and as a rebellious school uniform by Britney Spears in the 1990s. Shows like *Ally McBeal* and *Melrose Place* put powerful working women in power suits featuring miniskirts. Even though it's become part of almost every woman's wardrobe, from secretaries to ambassadors, the miniskirt remains a symbol of feminine power and confidence. It's a look so threatening to some that, as recently as 2015, a city in Alabama entertained a proposal to ban the miniskirt.

The Naked Dress

The Naked Dress—a term coined by the *Sex and the City* character Charlotte York—ranges from a skin-toned full coverage dress like the Calvin Klein slip dress Carrie Bradshaw wears on the show to a sheer illusion, sometimes covered only with strategically placed rhinestones, beading, or lace. The Naked Dress has been worn by bold women as long ago as the 1790s, when Parisian women walked the streets in semi-sheer muslin gowns over flesh-colored body stockings that had French writer Louis-Sébastien Mercier gripping his quill to record the look as *à la sauvage* ("wild"). In 1925, Clara Bow wore one with strategically placed Art Deco patterns in her silent film *My Lady of the Whim*. The 1930s brought Jean Harlow rocking many a clingy, solid-silk bias-cut Naked Dress and Mae West enrobed in a parade of glamorous beaded sheer gowns. But this form-fitted statement of confidence reached its peak potential when Marilyn Monroe wore a rhinestone-studded sheer dress for her iconic "Happy Birthday, Mr. President" performance for John F. Kennedy in 1962. Designed by French designer Jean Louis, the skin-toned, form-fitting gown featured over 2,500 rhinestones. Carroll Baker followed in 1964 with a Balmain gown studded with rhinestones and paired with a rose-adorned cape for the premiere of her film *The Carpetbaggers*. Both fashion statements featured daring, glamorous women owning their bodies as if they were the goddess Aphrodite herself, born of glittering seafoam and pearls.

More sheer and risqué versions of the dress were yet to come. In 1998, Rose McGowan made it rock 'n' roll by wearing a chain-mail dress with a black thong to the MTV Video Music Awards. Fast-forward to 2014: Rihanna rocked an incredible sheer yet bejeweled Adam Selman gown made out of 230,000 Swarovski crystals with a matching durag to accept her CFDA's Fashion Icon of the Year award. At the 2015 Met Gala, three naked dresses hit the red carpet on Beyoncé, Jennifer Lopez, and Kim Kardashian.

The Naked Dress is for icons. It's for all shades of nude, and all shapes of bodies. The Naked Dress is about being fully in command of your body, and that's the ultimate power play.

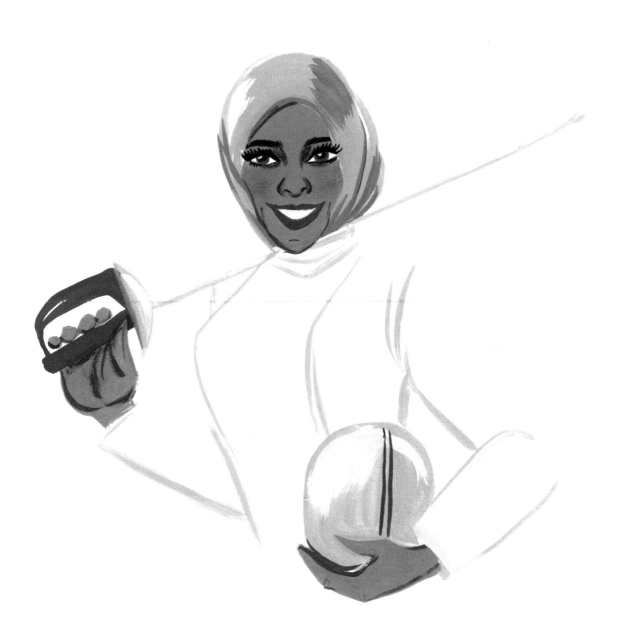

the Olympic Hijab

In 2016, New Jersey–born Ibtihaj Muhammad became the first Muslim woman to win a medal in the Olympics while wearing a hijab in competition. The bronze medal–winning fencer competed as part of the US women's saber team in Rio de Janeiro and has been a part of the US world champion fencing team since 2014. Muhammad was an active kid, playing many sports, but was often teased by peers for her uniforms that covered her arms, legs, and head due to her religious beliefs.

At the age of twelve, Muhammad and her mother drove past a group of high school girls fencing on a campus and saw that their uniforms covered the athletes from head to toe. That approach allowed Muhammad to observe her Muslim beliefs while also embracing her athletic ambitions, so her mom encouraged her to start fencing. Soon she was training at the Peter Westbrook Foundation (a center for underserved youth) and competing locally—often as the only African-American or Muslim female. Fencing is challenging to participate in because it is both expensive and difficult to access, which already limits the diversity of people competing in the sport. So even when Muhammad rose to join the Olympic team, she still faced discrimination and mistreatment from her teammates and coaches, something she's spoken openly about since winning her medal. Even after her historic win and the celebrity that garnered, she continued to face the harsh reality of living as a Muslim woman in the United States. When she arrived at the South by Southwest arts festival in Austin, Texas, to speak on a panel, she was harassed at check-in to remove her hijab for her ID photo. Muhammad has risen to be a face and a voice for young Muslim people everywhere, accessing and normalizing hijabs in spaces that had previously excluded them. That's why what you wear can be so meaningful.

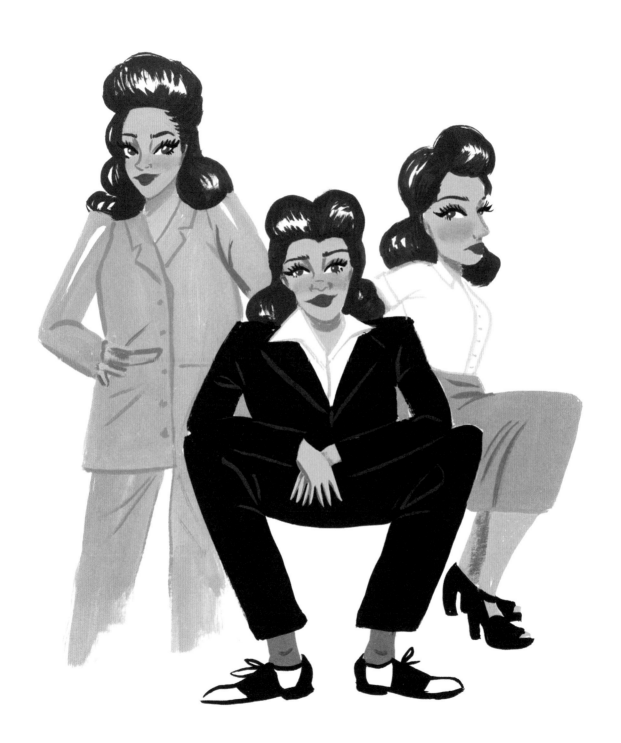

The Pachuca

In the 1940s, many second-generation Mexican Americans were caught between two worlds: the traditional, conservative culture of their parents and the new culture they were raised in but not truly a part of. This tension got worse when more young Mexican-American women started working in factories during World War II, gaining newfound independence through earning their own money and being part of a larger community outside their homes.

During this time, young Latino men adopted the zoot suit as an act of rebellion against institutionalized racism. Young women adapted it for their own style—soon to be pegged "pachuca." The zoot suit, born in 1930s African-American communities in Harlem, Chicago, and Detroit, featured high-waisted, wide-legged, pegged pants and a long jacket with wide lapels and padded shoulders. The excessive use of fabric was a direct revolt against war rations and considered unpatriotic. In Southern California, the media portrayed these newly zoot-suited Latinx teens, or "pachucos/as, as disruptive and violent; law enforcement arrested them disproportionately and served them excessive punishments. Meanwhile, their Latinx families were also wringing their hands. In a culture where women couldn't even be home alone without being chaperoned by a male family member, they feared that young women adopting rebellious attitudes would mean the deterioration of ancestral family values. These families also worried about keeping their rebellious children safe in a system that was already set up against them.

The teens used fashion to further their revolution, embracing their own heritage and creating a new blended one in a society that demanded that they whitewash it. Young Latinas' newfound earnings were spent on tailor-made zoot suits of their own, often paired with short pleated skirts and accessorized with dark red lipstick, thinly plucked eyebrows, and ratted-up pompadours hiding razor blades.

Pachucas embraced their new emboldened role as modern Mexican-American women and spent their nights out jitterbugging in unchaperoned clubs with other Mexican and Black teens. Girls expressed their pride, identity, and sexual independence through their dress, and even formed girl gangs called the Cherries or Black Widows, which further enforced the archaic and patriarchal society's view that these girls were sexually loose and unclean. Unsurprisingly, their male counterparts were not seen the same way—rather, they were seen as rebellious and macho to stand up to society's standards.

Things came to a head at the Zoot Suit Riots in Los Angeles—incited by the framing and indictment of seventeen young Mexican Americans for a murder they didn't commit. Pachucas played an important role during those riots and the events that led up to them, and their contributions further complicated their role in society. The rise of the pachuca mirrored the anxiety society had around women and minorities gaining independence and a voice, as it signaled that Mexican-Americans wouldn't accept their second-class status forever. And young Latina's own communities considered their new independence a sure sign of delinquency. Pachucas touched on society's fear that women wouldn't want to return to submissive, domestic lives when men came home from war. And they were absolutely right. A revolution started with a fashion rebellion.

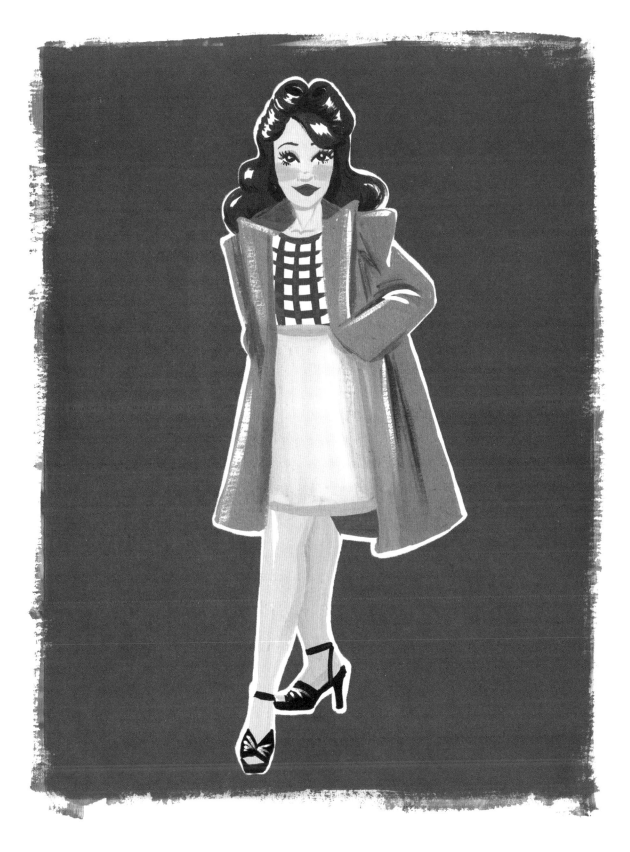

the Pants

Katharine Hepburn, first lady of wide-legged pants, was one of the great early feminists in Hollywood. A daughter of progressive New England parents (a doctor and a suffragette), Hepburn was a tomboy who loved to dress up in her brother's clothes, play sports, and keep her hair short. When she first appeared on-screen in 1932's *A Bill of Divorcement*, the audience didn't know what to make of a woman who was outspoken, sharp, and commanding. She found a home as a leading heroine in screwball comedies, able to go head to head with her quick-quipping male costars. Her personal style of wearing pants started to catch on, despite society's fear that women were trying to masquerade as men and soon wouldn't need men if they continued to wear slacks.

Like fellow stars Greta Garbo and Marlene Dietrich, Hepburn wore trousers on film and in her personal life. But no one did it as confidently and androgynously as Hepburn; for that, her studio, RKO, tried to stop her. They once stole her jeans from her dressing room, but she trotted around the set in her underwear until they were returned. Hepburn persisted as a symbol of strong, independent women everywhere, wearing whatever she pleased. What was striking about Hepburn wearing slacks was that she paired them with her confident personality and progressive views. She was a master class in the dualities of a woman: Her glossy '40s locks were glamorously set above her loose suit jacket and slacks. Her flowing gowns had structured shoulders, like a suit jacket. Even her life partner choice was unconventional—the still-married Spencer Tracy, whom she would stay with until his death. She loved making films but hated Hollywood; she won four Academy Awards but never showed up to claim a single one. The patriarchal society tried to penalize her for her choices, and she just kept being herself—independent, charismatic, and a role model for the women who showed up to see her in film. Pants became more popular when World War II made them a necessity in the factories where women worked while men served abroad—but Hepburn helped

normalize wearing pants, showing them as a symbol of feminine power and not masculine envy. The fight for pants continues even to this day—in 2017, female golfers were fined for wearing leggings, and at the time of this book's writing, women in Sudan can still legally be whipped for wearing trousers. Every time you pull on pants, think of it as a small act of resistance against a gender-discriminating norm.

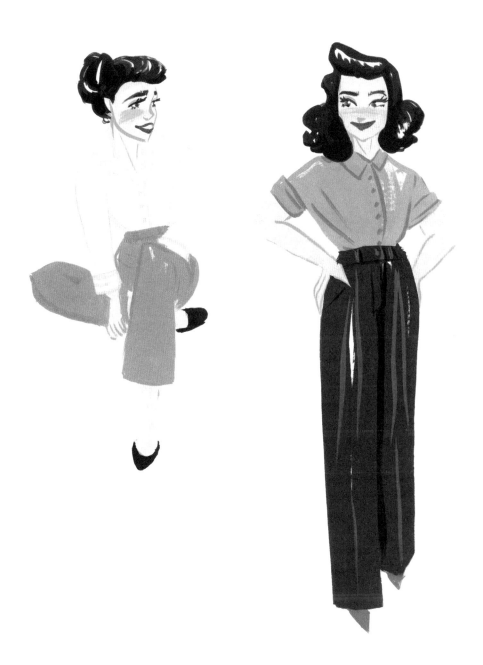

The Pasty

Rapper Lil' Kim is often hailed as the queen of hip hop, and she didn't get there by accident. Before her debut album *Hard Core* dropped in 1996, Kim was hustling hard as the only female member of hip hop group Junior M.A.F.I.A. She shaped her entire narrative by playing into men's fantasies while seizing the true power—money and a platform. She was packaged as sexy feminism, because she was the authentic embodiment of it. Her hardcore lyrics and openness about her personal life helped women reclaim their own sexualities as well. Kim paved the path for so many young female artists to come, taking the bold-faced criticism and showing up looking fly to every event anyway. Soon, she was sitting front seat at fashion shows and then walking the runways themselves. Her style spoke just as loud as her words because she was so authentically powerful and expressive.

There's no better example of this than the 1999 MTV Video Music Awards, when Lil' Kim showed up in a one-sleeved lavender jumpsuit that featured a sequin-shelled nipple pasty covering her left breast. The custom outfit was a brainchild of Kim and her stylist Misa Hylton-Brim, who created it from fabric that's typically used for wedding saris. Sequined shell patches were cut out of the fabric to make the custom nipple pasty and arm patches that accessorized Kim's look. She paired it with a long lavender wig and bejeweled platforms. This custom soon-to-be iconic look would be all Kim. Her over-the-top glamorous style expanded the idea of what a female rapper could be. This outfit was cemented in history when, as she was presenting an award with the legendary Diana Ross, Ms. Ross reached over and bounced Kim's breast with bemusement. It was the passing of the torch from one legendary diva to another.

This bold sartorial move was a precursor to the Free the Nipple movement that started in the aughts. Pasties have become commonplace on the red carpet, a marker of daring and glamor worn by self-possessed celebrities like Rihanna, Nicki Minaj,

and Miley Cyrus. What started out as a circus and dance hall staple for female dancers in the 1920s quickly became a piece of feminist fashion. While burlesque stars like Dita Von Teese are keeping its roots alive, everyday women are embracing the pasty as a fashion accessory in places like music festivals, where the body positivity movement is rising. The nipple, after all, is a part of the body and can get dressed too.

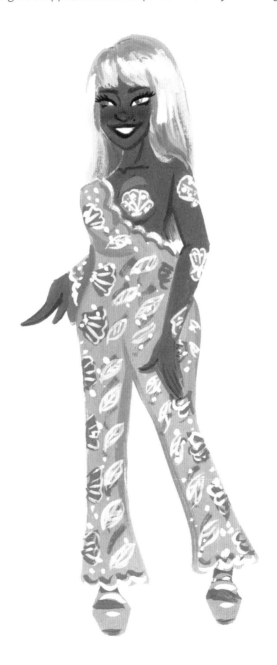

the Pink Pussyhat

After the divisive 2016 US presidential election, people across the country were enraged that a candidate who was publicly abusive toward women, minorities, immigrants, and many marginalized populations had been elected despite not winning the popular vote. Communities started to gather and organize, and two major movements were created: the Women's March, which would happen in Washington, DC, and cities across the country on January 21, right after inauguration day, and the Pussyhat Project.

Created by two Los Angeles–based friends, Jayna Zweiman and Krista Suh, the pink pussyhat started out in a knitting circle. While recovering from a serious injury, Zweiman took up knitting and persuaded Suh to attend classes with her at a local knitting shop, Little Knittery. Suh shared her plans for attending the Women's March in DC, and Zweiman was disappointed by her inability to physically participate. But they realized Suh would need a warm hat for DC, and came up with the idea of the Pussyhat Project. They brought in Little Knittery owner Kat Coyle to help design a pattern that could be made by knitters, crocheters, and sewers alike—something simple enough that anyone could participate if they wished. Soon, the pattern and project went viral. People were encouraged to make hats for friends and family, and donate them to local drop-off sites, to be distributed at the march. The name of the project was inspired by championing all things feminine—like the color pink—and reclaiming a derogatory term that had been subjugated by the forty-fifth president in a leaked audiotape where he bragged that he could just "grab [women] by the pussy."

Come the morning of January 21, a sea of pink hats, just as Suh and Zweiman had dreamed, flooded the streets not only of Washington but of cities all around the globe. The pink hat became such a symbol for the women's movement and

resistance against a misogynistic administration that it appeared on the covers of the *New York Times Magazine*, *Time*, and the *New Yorker*. Soon, the hats even found their way onto a Missoni runway show.

Founded in the humblest of places—a knitting circle, a place that has long been a safe space for women—the pink pussyhat became a symbol of rebellion that could provide access for many people to channel their energy into something positive: a visual emblem showing we are all in this together. Although there have been detractors of the hat—with critiques of the color as symbolic of white genitalia and thus not inclusive of women of color, and of the hats excluding trans women because not all women have pussies—this fashion lesson has opened up the conversation on how to be more inclusive and supportive of our communities going forward. With that, the pink pussyhat will hopefully be the first of many protest fashions to come in this era.

The Pixie Cut

After the popularity of bobs faded in the 1920s, interest resurged in 1953 when Audrey Hepburn cropped off her long royal hair as Princess Ann in *Roman Holiday*. In the scene where Ann scandalizes a hairdresser by asking for shorter and shorter hair, the pixie cut was born. Soon, Leslie Caron followed suit in *An American in Paris*—a scandalous choice by the actor, who cropped off her own hair when her stylist refused to do it. In 1957, actor Jean Seberg cut her hair super short to play Joan of Arc and grew it out just a touch for the French New Wave classic *Breathless*. Mia Farrow surprised everyone on her show *Peyton Place* with a home-cropped pixie, and it sent the studio into a mad frenzy. Farrow wrote: "I didn't ask for permission because I knew I wouldn't get it," and had to publicly apologize for her choice. She later became famous for her pixie cut in *Rosemary's Baby*.

Finally, in the early 1960s, Vidal Sassoon invented the five-point cut—a short women's style that models like Twiggy and Edie Sedgwick made all the rage for trendy young girls. Even after the hairstyle was embraced by the fashion world and normalized in society, pixie cuts remained a statement of independence that often garnered unsolicited public reaction. Look to Keri Russell's infamous cut on season 2 of *Felicity*, which became a cautionary tale—many correlated her unpopular short hair with a major ratings drop the show never recovered from.

The controversy of short hair on women continues to this day, and it's because long hair is seen as a symbol of fertility and femininity—the two roles that society is most comfortable with women playing. In 2009, *Elle* magazine ran an article about how pixie cuts affect a woman's ability to find love because men prefer princess hair (who cares?!). In 2017, Katy Perry had to make a public statement about her newly bleached-blond pixie, saying that she not only wanted to shed the old Katy but also to "feel so liberated from all the things that don't serve me."

Every time a woman gets a pixie cut, she's reclaiming her power and reminding society that we hold our own liberation through our choices.

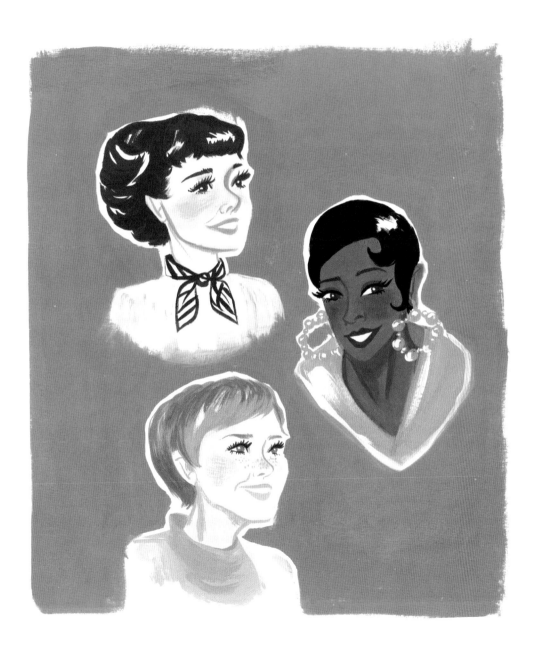

the Plunge Dress

In 2000, Jennifer Lopez became a household name and singlehandedly caused the need for Google Images. The former *In Living Color* Fly Girl had become a Golden Globe–nominated actor in her starring role as Selena Quintanilla in 1997, establishing a career where she'd become the highest-paid Latinx actor in Hollywood. In 1999, she had just released her first solo pop album to major success. She was dating Sean "Puffy" Combs. And when they arrived at the 2000 Grammy Awards, all eyes were on her in a navel-plunging, sheer, green palm-printed Versace gown. The silk chiffon dress was fastened together by a bejeweled brooch just below the belly button. In less than twenty-four hours, her photo had been downloaded more than half a million times from the Grammy website. Google executives later wrote that J. Lo's green dress became the most popular search query the site had ever seen and the reason Google Images was invented.

One of the most interesting things about this gown is that Lopez wasn't even the first to wear it. The green gown was featured in Versace's 1999 runway collection and in Versace ads on model Amber Valletta. Donatella Versace herself wore it down the 1999 Met Gala red carpet, and Spice Girl Geri Halliwell donned it, to total silence, for the NRJ Music Awards in France a month before the Grammys. What that really says is that it's all about the woman in the dress rather than the dress itself. Lopez reached her peak potential in a dress that only she could rock. It's that "it" factor that also made her the most influential and powerful Latinx entertainer in Hollywood—and the confidence and power gained through her hard work literally made her glow. The most valuable lesson here is that no matter how you choose to let fashion reflect you, you always want to be wearing the clothes and not letting the clothes wear you.

The Presidential Pantsuit

Pantsuits have a long history, stemming from when Marlene Dietrich first donned a tuxedo (see The Tuxedo, page 111). Coming into its cultural moment in the 1980s with broad shoulder pads and boxy cuts featured in Hollywood shows like *Dynasty* and films like *Working Girl*, the female suit has always been associated with women and power in the workplace. But no one has more cachet in a power pantsuit than Hillary Clinton.

Clinton could be seen in a pantsuit as early as her twenties, working among the inquiry staff during Richard Nixon's 1974 impeachment hearings. She claimed the pantsuit as her signature style throughout her political career because it's practical and comfortable—two things that women's clothing have historically been missing. Clinton was the first US First Lady to wear a pantsuit in her official White House portrait. Clinton strategically took the controversy-baiting topic of her clothes off the table by making a simple statement that supported her power and function. She even poked fun at her own penchant for pantsuits. Clinton used color to express her themes, in the same way male politicians do with their tie choice. When she accepted her nomination as the first female presidential candidate of a major political party at the Democratic Convention, she wore white as a nod to the suffragettes who came before her. Many white pantsuits were worn on her presidential campaign trail. When she gave her concession speech, she chose purple as a nod to bipartisanship.

The politics of the pantsuit is complicated—women started commonly wearing pants during World War II because they were working in factories. But just a decade before that, women were arrested for wearing slacks in a Los Angeles courtroom. Not until the 1970s would women's pants become mainstream—around the same time that over 43 percent of women joined the workforce and Title IX of the Education Amendment allowed girls to wear pants in public schools. Pants have always been tied to women's emancipation both physically and in the workforce (see The Pants,

page 78)—even on the most powerful floor of all. Women were banned from wearing pants on the US Senate floor until 1993, when Senators Barbara Mikulski, Carol Moseley-Braun, and Nancy Kassebaum became the first to challenge the rule. Now wearing a pantsuit everywhere from Capitol Hill to the red carpet is a non-issue—thanks to all the women, including Clinton—who insisted on claiming it as their own.

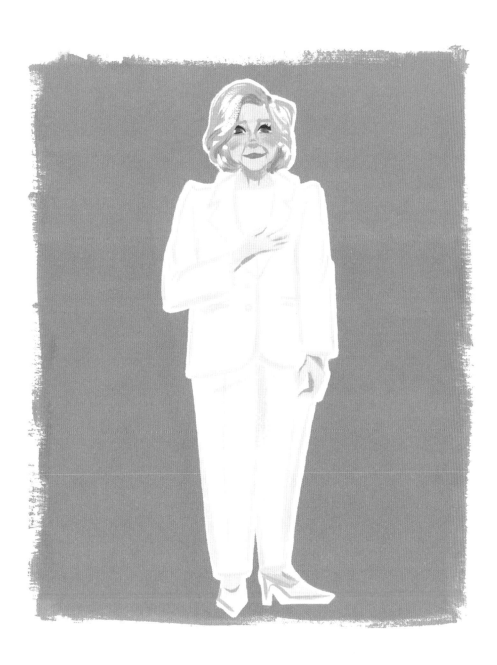

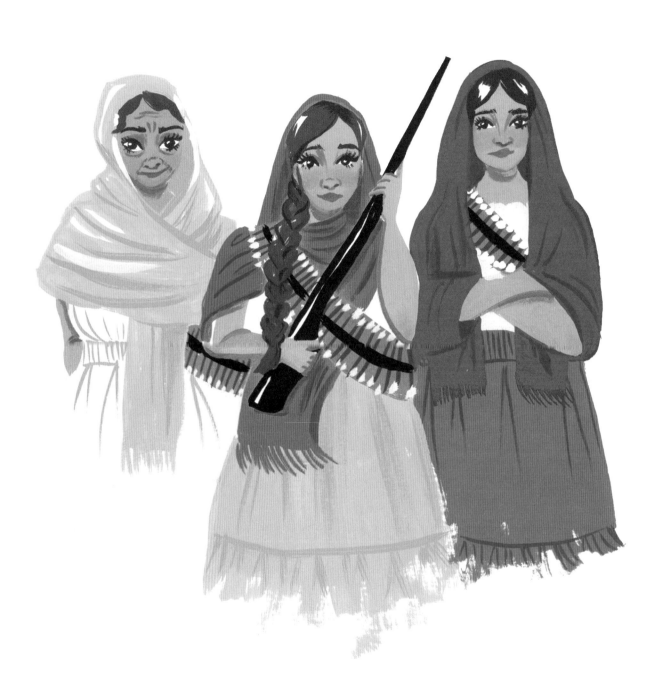

The Rebozo

During the 1910 Mexican Revolution, the rebozo became a symbol of rebel women, also known as *adelitas*. A shawl worn from birth to death, the rebozo is a traditional handwoven wrap hailing from precolonial times in Mexico. It was influenced by colonial settlers as they brought different dye techniques and fibers into the villages. Depending on the region of origin, they can have simple pattern weaves, stripes, embroidery, fringe, ikat, or beading, and can be made from cotton, wool, silk, or rayon. Rebozos were often used to help women in childbirth, carry babies or large bundles, provide warmth or sun coverage, or drape over the head for modesty in churches. Women would also wear rebozos as a symbol of their marital status—wrapped loosely and covering their chest if they were married, wrapped over their heads and showing their blouse if they were single and available. Rebozos were also used as funeral shrouds to bury the dead in. By the 1800s, all women in Mexico, regardless of their indigenous or mestizo background or social class, wore some form of rebozo.

So during the Mexican Revolution, courageous adelitas wore this humble shawl around their bodies to smuggle weapons and babies past federal checkpoints, helping the resistance. The rebozo became synonymous with the heart and craft of Mexico—representing its very keepers, the women of Mexico. From then on, prominent women like artist Frida Kahlo, actress María Félix, and former Mexican first lady Margarita Zavala Gómez del Campo all embraced the rebozo as a symbol of their heritage pride and feminist history.

the Red Lipstick

What do flappers, sex workers, monarchs, starlets, congresswomen, showgirls, and suffragettes have in common? They all wear red lipstick. There's no other tool of female empowerment that is as uniquely powerful and feminine as red lipstick. Unlike other fashion statements that co-opt traditionally masculine fashion as their own, lipstick is historically, uniquely feminine.

The decision to wear red is a bold one—to show up and be seen. It takes confidence and discipline. Both Queen Elizabeths had red lipsticks bespoke for their coronation days and all their days after. Suffragettes created a uniform of white dresses and red lipstick. During a 1912 New York City protest, Elizabeth Arden opened her shop doors to pass out red lipstick, like water to marathoners. Lipstick is so important that even during wartime, cosmetics were never rationed. During World War II, women in Allied countries wore red lipstick to show opposition to the Nazi regime. Hitler was notorious for his hatred of red lipstick and makeup. It's downright anti-Nazi to wear red lipstick!

The crimson lip has evolved throughout the ages, and red has always meant rebellion, power, and strength. In 2018, Alexandria Ocasio-Cortez—the youngest congresswoman ever, at age twenty-nine—wore red lipstick and gold hoops to her swearing-in ceremony to the US House of Representatives. Ocasio-Cortez credits her outfit as a nod to a woman who cracked that glass ceiling before her: Supreme Court Justice Sonia Sotomayor. Sotomayor was the first Latina woman to serve on the highest court, and had been advised to wear neutral nail polish instead of red for her confirmation hearings to avoid scrutiny. She didn't listen to that advice.

Red is for women—all women. It's a statement that women are here to be seen, to be heard, and to be strong. In a society where women feel pressured to not only wear makeup and accessories but the right kind, Ocasio-Cortez says, "The next time someone tells Bronx girls to take off their hoops, they can just say they're dressing like a congresswoman."

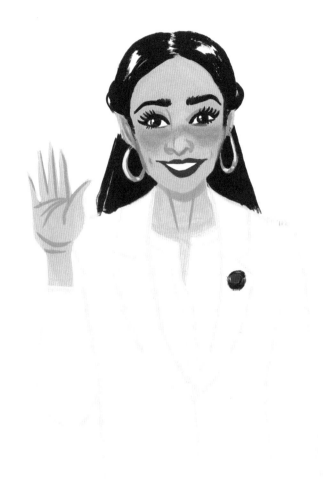

Lipstick can start a revolution

Under an oppressive communist regime that even dictates its citizens' appearances, North Korean women have created a market of smuggled beauty products—including nude lipstick. Bright makeup and hair dye are forbidden in the country, especially imports from other countries. But these women wear smuggled lipstick and makeup close to their natural coloring just to resist the domineering rule over their lives. Even subject to public humiliation and criminal charges, a growing number of North Koreans revolt by taking agency over their own bodies, creating small changes that can lead to greater freedom.

the Revenge Dress

In June 1994, Diana, Princess of Wales, entered a new style into the fashion lexicon: the Revenge Dress. The same night that Prince Charles admitted to adultery during their marriage on national television, Diana made a solo appearance at a fundraising event for the Serpentine Gallery in London's Hyde Park. The next day, her form-fitting, off-the-shoulder black silk cocktail dress by Greek designer Christina Stambolian stole the headlines.

Interestingly, Diana had another dress in mind for the function, but after reading a press statement from Valentino that she called "crude opportunism," she switched to this now-iconic little black dress that had been custom made for her three years prior. She hadn't worn the dress before because she thought it would be too daring for a royal. But now, after three years separated, and catching wind of Prince Charles's admission going live that night, she told her stylist Anna Harvey that "she wanted to look like a million dollars." And she did.

The confident, independent woman that stepped out that June evening became a global queen and turned a painful, humiliating moment into her personal victory. Accessorizing with pearl earrings and a choker, Diana made a public statement, breaking with royal protocol and the royal family itself without saying a word. She stepped straight out of her role as a shy princess into her next as a glamorous, self-possessed woman. And the Revenge Dress was born.

the Rolled Stocking

In addition to drop-waisted dresses, bob haircuts, and cloche hats, 1920s flapper girls also pushed boundaries with rolled stockings. At the time, women were expected to wear stockings that were attached by cumbersome garter straps on girdles, so they were covered from head to toe. Stockings were costly; they came mostly in cotton, silk, or rayon and easily got runs—causing another financial and mental burden for women.

Flappers cast off bulky garter belts and girdles by adapting an elastic, cloth-wrapped band (called "roll garters") that they pulled up to the top of their stocking, then rolled their stocking down over. Some especially daring girls rolled their stockings low and rouged their knees to elicit even more attention. Showing knees was scandalous at the time, and the flappers leaned into it. They didn't just wear rolled stockings with dresses; they even wore them with swimsuits at the beach. Stockings came in various pastel colors, patterns, and fabrics. This trend became so popular that it was even the title of a 1927 film, *Rolled Stockings*, starring Louise Brooks, one of the quintessential flapper queens of the silver screen. Funny how a little trend like rolling an existing piece of clothing can be such a quiet rebellion.

the Safety Pin Dress

In 1994, then-little-known actor Elizabeth Hurley accompanied her boyfriend, Hugh Grant, to the premiere of his film *Four Weddings and a Funeral*. The next morning, she was an international celebrity, all because of a little black dress. Designed by Gianni Versace, the black dress she borrowed as a favor from the designer was made of silk and Lycra and was held together by giant gold safety pins, with zippers as adornment. It was the only thing Grant's people had to offer her when she couldn't afford a dress for the red carpet. It was destiny.

Hurley was the first actor to blow up the red carpet. Prior to this, actors dressed more conservatively and formally. What's even more notable is that this wasn't even a premiere for a movie she was in, so her stealing the headlines invented the very idea of modern celebrity publicity. The headlines surrounding her dress made the cocktail dress casual, accessible—and the legend of how she came to wear it sounds like a Cinderella story for the modern woman. Just slip on a Versace dress, and you'll be the belle of the ball. Hurley was one of the first modern actors to own the male gaze and make news with her image. And Versace was the perfect brand to do that with; the designer specialized in a brand of neo-punk, neo-feminist sexual empowerment. When responding to critics of the dress, Hurley replied: "Unlike many other designers, Versace designs clothes to celebrate the female form rather than eliminate it."

the Sleeveless Shift

When Michelle Obama stepped into her role as First Lady of the United States, who knew that it would be her well-toned arms that lifted the United States emotionally out of the greatest recession since the Great Depression? A Harvard-trained lawyer and mother of two, Obama stirred controversy by showing up to her husband President Barack Obama's first congressional address in a purple sleeveless dress that gained as much attention as the president's actual words. Then, just one month into the presidency, the first lady appeared in her official White House portrait in a sleeveless black shift gown. It sent the media and public into a frenzy: It was "Sleevegate" and "The Right to Bare Arms" on both sides of the political spectrum.

It's kind of wild to imagine that in 2009, a sleeveless woman in a professional shift dress would launch so much debate. Perhaps it was because the rest of the news at the time was too depressing: The stock market was in shambles, faith in the American economy was gone, and the richest 1 percent had sunk the rest of the country. Michelle Obama's arms came in like a beacon of hope, a toned and warm embrace, and for that, she was equally loved and feared. Her critics claimed that it was unprofessional, but Jacqueline Kennedy, the zenith of first lady chic, was often photographed in sleeveless shift dresses. The critiques of Michelle Obama's dress often reeked of racism and sexism, a joint prejudice called *misogynoir* (coined by queer Black feminist Moya Bailey). The critics were uncomfortable with a first lady showing her arms because it was *this* first lady—the first Black first lady, with the first Black president. She presented herself as intelligent, thoughtful, compassionate, kind, and strong—all things that were threatening to people who didn't agree with her husband's or his political party's politics.

There seems to be a sexist idea that one can only be intelligent or attractive—and that it's OK for men to not care about their appearance because they're doing

the intellectual work, while women's value lies only in their appearances. Michelle Obama tore that down with her toned arms, while showing discipline, compassion, and intellect. She was a hugger, often seen embracing constituents along the campaign trail and then as first lady. Even she didn't know her arms would become such a subject of conversation. She varied her outfits and, when asked about it, would wryly mention that she did indeed cover up her arms more now. But it was the least of her concerns. As she stated in a 2008 interview with *Essence* magazine: "If I wilted every time somebody in my life mischaracterized me, I would have never finished Princeton, would have never gone to Harvard, and wouldn't be sitting here with Barack."

The Slip Dress

Descendant of Marie-Antoinette's scandalous *gaulle*, the slip dress became a silver screen staple for difficult, strong women in the 1950s. An early predecessor in the 1930s, the bias-cut gowns favored by Jean Harlow featured a silky dress that draped over (and emphasized) a woman's underwear-less curves. In 1958, when Elizabeth Taylor stripped down to her iconic white slip in the film *Cat on a Hot Tin Roof*, the slip dress's rebellious, risqué reputation was cemented. Liz was a fiery, glamorous woman staging her own rebellion. Though she never wore it out in public, the slip was so potentially controversial that a special opaque one had to be made just for the costume; traditionally slips were sheer undergarments. Even then, it caused a stir when the film came out.

In the 1983 film *Scarface*, Michelle Pfeiffer's character unifies the Harlow silk, minx-style gown with the Taylor slip silhouette as her signature style. Her character is elusive, yet her wardrobe leaves little to the imagination. One might call it the true power structure of a woman: soft on the outside, steely on the inside. The dichotomy challenges moral boundaries of each era; it's breaking down restrictions literally placed on women's bodies.

In the 1990s, the slip dress trend reached a fever pitch. Films like *Waiting to Exhale* gave us an iconic scene with Angela Bassett walking away in a slip and white jacket after setting her cheating ex-husband's car on fire. Courtney Love made the slip dress grunge. "It girls" Winona Ryder and Kate Moss made it the marker of '90s cool. And Carolyn Bessette made it American royalty when she married John F. Kennedy Jr. in a Narciso Rodriguez white slip dress. The versatility of the slip dress has persisted as a staple of many closets to this day. Just ask Rihanna, a modern-day purveyor of the slip dress. The slip dress is the sartorial choice of the cool girl who doesn't try too hard but looks effortlessly chic and powerful—it's a look that says "I'm completely comfortable in my body." And that's the most radical attitude of all.

The Swan Dress

Likely one of the most memorable dresses to ever walk the red carpet at the Academy Awards, Icelandic superstar musician Björk's 2001 swan dress is an icon of "to thine own self be true." Originally created by Macedonian designer Marjan Pejoski for his 2001 fall/winter runway collection featuring a merry-go-round theme, the swan was just one of the creatures in the show. Björk chose it as her Oscar gown when she was nominated for Best Original Song for "I've Seen It All" in *Dancer in the Dark* (in which she also starred). To accessorize the swan dress, she brought along six ostrich eggs to "lay" along the red carpet. The dress caused a sensation, but Björk shrugged off the negative press, insisting, "It was just a dress."

By that time, Björk had already released three solo albums and was widely renowned for her songwriting and unique point of view. The swan dress also made an appearance on the cover of her *Vespertine* album later that year. She stated that she knew it would likely be her first and last time at the Academy Awards, so why not pay tribute to the over-the-top glamour she associated with Hollywood, gleaned from watching Busby Berkley and Esther Williams musicals.

The early aughts were an especially bleak era for anybody wanting to stand out. Though frequently mocked at the time, the swan dress has since been exhibited at the MoMA, inspired a 2014 Valentino collection, and been shown at the Metropolitan Museum of Art's Fashion Institute exhibition for 2019's theme of *Camp*. The very definition of camp in fashion, taken from Susan Sontag's 1964 essay, is a "love of the unnatural: of artifice and exaggeration." Home of spectacle, artifice, and exaggeration, Hollywood's Academy Awards is, in a way, the perfect place for camp fashion. Björk came dressed for the occasion, enabling all the little weirdos watching at home to feel seen within a sea of conformity, proclaiming the power of being different.

the Tennis Catsuit

When one of the world's greatest tennis players, Serena Williams, returned to Grand Slam tennis in 2018, months after giving birth to her daughter, Olympia, it was her outfit that made the headlines. Donning a sleek, black Nike catsuit with a red sash, Williams was addressing her health issues with the compression material—she developed blood clots after a difficult pregnancy and birth—and making a fashion statement fit for royalty. Superhero Black Panther royalty, to be precise. Of her catsuit, Williams said, "I feel like a warrior princess . . . like a superhero when I wear it." Fitting words for a woman whose legacy, career, and strength has made her a real-life super-hero to so many people, and now mothers, around the world. Sadly, French Tennis Federation president Bernard Giudicelli didn't agree, and banned the uniform from future French Open tournaments.

To understand why such a seemingly innocuous and functional sport outfit would be so controversial, take a look at the historically elitist and sexist roots of tennis. The sport gained popularity with the Victorian upper class, and tennis whites became the norm because white clothes were reserved for the wealthy. To this day, tournaments such as Wimbledon still enforce an all-white dress code. Though styles of tennis dress evolved with fashion trends (corsets in the Victorian era to flapper skirts in the 1920s to cardigans in the 1950s), Gertrude Moran still caused a major stir in 1949 when she wore a skirt with lace shorts underneath on the court. When the shorts were revealed during the action of the game, she was persecuted in the tennis world media for bringing "vulgarity and sin into tennis." The sexist roots don't end with wardrobe: Wimbledon still lists female players on the board by their marital status and husband's name (i.e., "Mrs." and the player's husband's last name—even if some, like Williams, don't change their names after marriage). And in tennis, as in most professional sports, women athletes have been advocating for equal pay to the men.

Williams's catsuit wasn't the first to cause a stir in the tennis world. In 1985, Anne White wore an all-white suit and was accused of being too attractive and distracting. In 2002, Williams wore a short catsuit for the US Open and was criticized for appearing too vulgar and muscular. These media critiques demonstrate overt sexism, racism, and body-shaming, making the case that women's bodies are too sexy, too strong, too much.

Williams and her sister, Venus, have long been the outliers of the tennis world: criticized for the way they dress and play, down to the minutiae of the beads they wore in their hair when they were adolescents in the pro game. And yet they keep winning. Regardless of what she wears, and what Wimbledon wants to call her, Serena Williams is a legend among humans and a real-life superhero queen.

The Tricolor Stripe

The fight for women's suffrage was spearheaded by clever individuals who knew how to harness the power of style and branding. In 1908, *Votes for Women* coeditor Emmeline Pethick-Lawrence furthered the brand when she wrote an article designating the suffragettes' color scheme as purple, white, and green. Purple for loyalty and dignity, white for purity, and green for hope. The colors made their public debut at the Women's Social and Political Union's "Women's Rally" in Hyde Park that saw 300,000 marchers.

After the attempt to adopt the bloomer suit (see The Bloomers, page 23) failed to help further their cause, suffragettes took to incorporating the tricolor stripe motif into their traditional feminine dress code. They learned that their outfits were gaining more attention than their message when the media focused on the bloomer suit, caricaturing suffragettes as unattractive outsiders in men's pants, thick glasses, and unappealing galoshes. By stigmatizing strong-minded women who wanted equality as unfeminine and radical, the media was isolating women from each other.

So the suffragettes took great care to rebrand themselves. *Votes for Women* declared that "the suffragette of today is dainty and precise in her dress" but encouraged supporters to wear the colors "as a duty and a privilege." It wasn't just radical women who wanted the vote; it was every woman. Soon, trendy London shops such as Selfridges and Liberty began supporting the movement by selling ribbons, rosettes, hats, badges, belts, jewelry, underwear, garments, shoes, and home goods in the tricolor motif. Supporters of the movement were able to accessorize with a cause. This showed more people were in support of women's right to vote than the press would have wanted the public to believe, and it became popular to support women's suffrage with the symbolic tricolor stripe. Landmark legal changes were adopted in the United Kingdom in 1918 and in the United States in 1920 that gave women the right to vote. And that's the power of style.

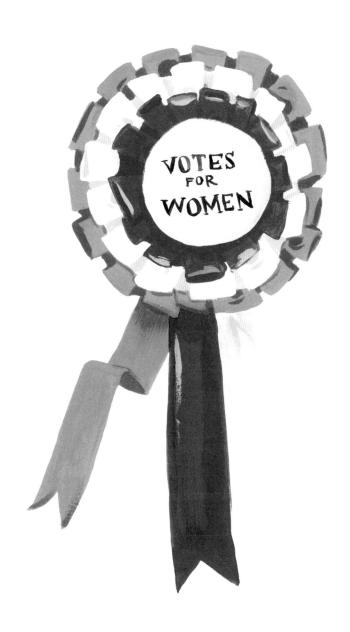

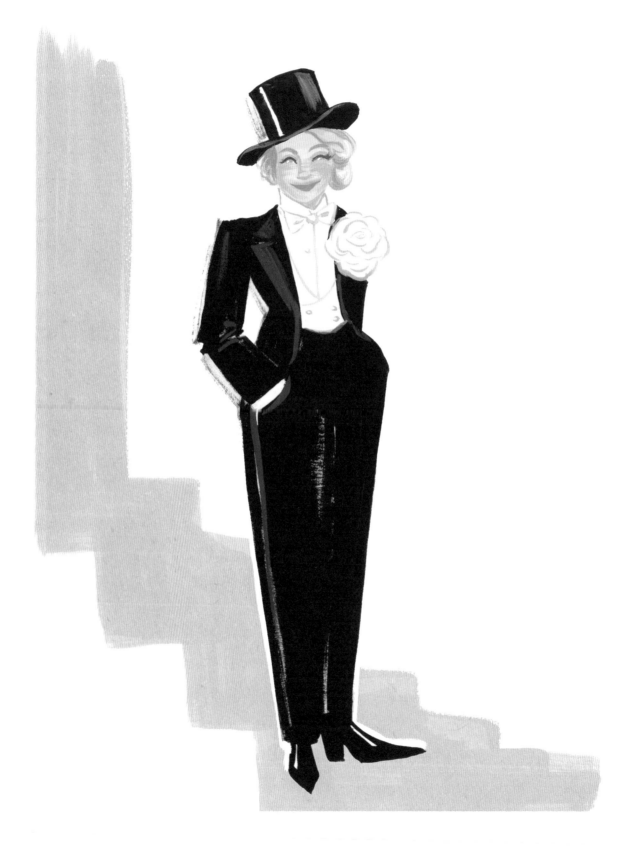

The Tuxedo

Glamorous Hollywood actor Marlene Dietrich first gender-bent the tuxedo in her role as a cabaret singer in Josef von Sternberg's 1930 film *Morocco*. In a time when women weren't even wearing pants in public, Dietrich rolled in with a top hat and donned the ultimate masculine fashion statement while performing a number that ended with her kissing a woman in the audience. Dietrich's outfit and behavior in this scene changed suits forever and became a symbol of female emancipation.

Dietrich herself represented confidence, sexual empowerment, and personal political power. She knew that image was everything in her career, and continued to push the envelope to shape hers, embodying off-screen the alluring yet fiercely independent women she portrayed on-screen. Her personal life was all about blurring the lines between masculine and feminine societal codes, often through her fashion choices.

In 1966, Yves Saint Laurent presented "Le Smoking," the first women's tuxedo, at his couture show and, more than thirty years after Dietrich debuted the style, it still shook the fashion world. But French stars like Catherine Deneuve and Françoise Hardy embraced the look and took it public. International icon Bianca Jagger even got married in a white YSL Le Smoking jacket. Contemporary stars such as Angelina Jolie, Awkwafina, and Janelle Monáe embrace the androgynous, sexy, powerful tuxedo for the red carpet, making a strong statement about female independence and confidence. It's the fancy version of the pantsuit, with all its connotations of power and gender-erupting politics.

the Tweed Suit

One reason Coco Chanel is one of the most famous and important designers of the twentieth century is that she innovated womenswear by incorporating menswear and sportswear into feminine fashion. When she invented her signature tweed suit in the early 1920s, she pulled inspiration from the closet of her boyfriend, the Duke of Westminster. Inspired by the fabric of his hunting jacket, Chanel found a Scottish twill mill to produce tweed especially for her. She became a master of elevating sport fabrics into luxury and comfort into high fashion. Chanel wanted to dress women for their lives instead of "upholstering women," a burn she threw at her contemporary competitor Christian Dior.

The first earth-toned Chanel tweed design became a sensation when actor Ina Claire was photographed in it for a 1924 magazine. Chanel often wore her lovers' clothes, looking slouchy and sophisticated in men's coats, and became a fashion icon herself. She created the cardigan-jacket in 1925, the little black dress (when black had traditionally been reserved for funerals), and the first tweed suit with a collarless jacket and straight skirt shortly after. She moved her tweed manufacturing to France, where more luxurious threads, such as silk, could be incorporated into the weave to create the unique, signature Chanel tweed. In a time when young girls were becoming flappers and women were recovering from the era of the Victorian corset, Chanel pushed their evolution to hyperspeed by making clothing even more comfortable and accessible for women.

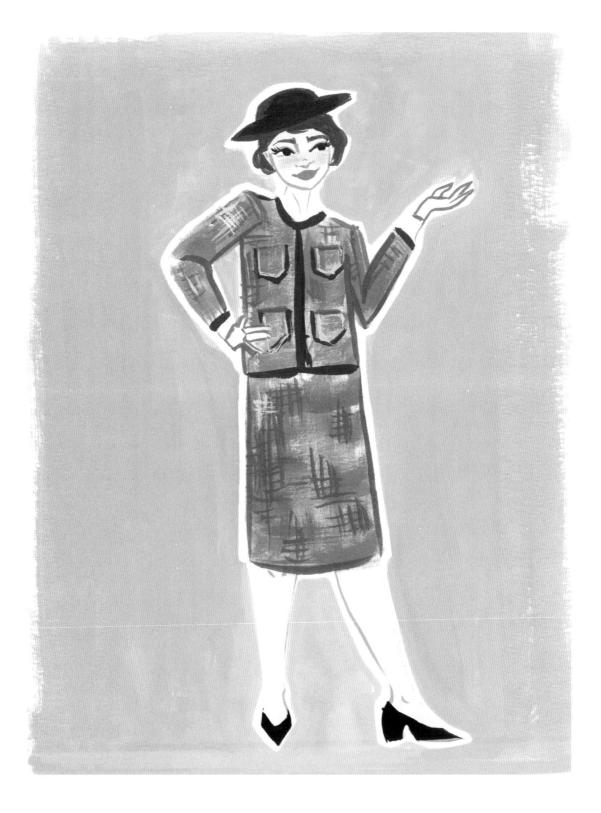

the Unibrow

World-renowned Mexican artist Frida Kahlo was as well known for her personal style as for her paintings. No one embraced the power of dress like Kahlo. Costuming herself in traditional Tehuana peasant dresses, embellished plaster corsets, braided hair, and flower crowns, Kahlo meticulously crafted herself into an icon of her mestizo Mexican heritage and personal convictions of communism, revolution, and feminism. But the Kahlo features that often spring to mind first are her unibrow and wispy mustache—both cultural taboos for women to this day.

Kahlo's acceptance of her natural facial hair was bold and unheard of at the time. She also embraced the masculinity and femininity in every person. She would as soon dress up in suits and pull her hair back tight for portraits (including self-portraits), presenting herself with the swagger of a man, as she would wear huipiles (woven tunics) with Mayan patterns and long embroidered skirts. A lover of both men and women, Kahlo became a positive global icon of queerness. She would darken her unibrow with eyebrow pencils, presenting a sharp contrast with her rouged cheeks and red lips.

Kahlo was an artist all the way through to her soul, and she knew that the way she presented in the world would be as symbolic and important as her artistic work. She pushed forward her ideals of equality and duality by embracing them in her image: the masculine and feminine, her European and Mexican heritage, her natural body hair and carefully groomed image. She wrapped herself up in these ideals like the rebozo she often wore as tribute to the adelitas of the Mexican Revolution (see The Rebozo, page 91).

the Wrap Dress

When a young European princess, Diane von Furstenberg, arrived in New York City with a suitcase full of wrap dresses in 1969, she didn't know she was going to revolutionize women's fashion. She had studied in Switzerland and apprenticed in the fashion industry in Paris and Italy, which would lead her to design her first silk jersey wrap dresses. Then freshly married, with a new baby in her arms, DVF was encouraged by friend and *Vogue* editor-in-chief Diana Vreeland to start selling her clothing designs. Her wrap dresses—modeled after ballerina wraps—were custom made by her friend and former boss Angelo Ferretti in his Italian factory. Though there were prior prototype styles, there wasn't one that fit just like DVF's: clinging perfectly to a woman's body, accentuating and concealing in all the right places.

The dresses were selling out as soon as they hit the sales floor. The fun and flirty DVF wrap dress embodied the 1970s effortless glamour of independent women. When asked how she came up with the idea, DVF demurely replied, "Well, if you're trying to slip out without waking a sleeping man, zips are a nightmare." This sentiment embodied the power and sexual independence women were gaining in the 1970s and continue to embrace today. Beyond that, it represents intelligence and polish alongside unapologetic femininity. Madonna wore one when speaking at a conference in Israel. First Lady Michelle Obama wore one in the Obamas' first White House Christmas card. Kate Middleton, Duchess of Cambridge, has worn many for her royal engagements.

The universal appeal of this dress is due to the power behind the woman who created it. As DVF herself says, "I understand women very well. If you understand yourself, you understand women, because in the end, all women are the same." It could be further said that all women are the same because they all want autonomy, confidence, and respect.

References

Beaton, Cecil. *The Glass of Fashion.* New York: Rizzoli, 2014.

Blackman, Cally. *100 Years of Fashion.* London: Laurence King, 2012.

Cole, Daniel James, and Nancy Deihl. *The History of Modern Fashion.* London: Laurence King, 2015.

Edwards, Lydia. *How to Read a Dress: A Guide to Changing Fashion from the 16th to the 20th Century.* London: Bloomsbury Visual Arts, 2019.

English, Bonnie. *A Cultural History of Fashion in the 20th and 21st Centuries: From Catwalk to Sidewalk.* London: Bloomsbury Academic, 2013.

Massey, Sarah, et al. *Dress Like a Woman: Working Women and What They Wore.* New York: Abrams Image, 2018.

Rissman, Rebecca. *A History of Fashion.* Minneapolis: Abdo Publishing, 2015.

THE AFRO

Campbell, Bebe Moore. "What Happened to the Afro?" *Ebony,* June 1982.

Dickerson, Jessica. "11 Afros That Make It Impossible Not To Love Black Hair." *Huffington Post,* March 4, 2014, https://www .huffpost.com/entry/famous -afros_n_5007671.

Edwards, Chime. "The Impact of The 'Fro In The Civil Rights Movement." *Essence,* February 10, 2015, https://www.essence.com /holidays/black-history-month /impact-fro-civil-rights-movement/.

Sherrow, Victoria. *Encyclopedia of Hair: A Cultural History.* Westport, CT: Greenwood Press, 2006.

Willon, Phil, and Alexa Díaz. "California becomes first state to ban discrimination based on one's natural hair." *Los Angeles Times,* July 3, 2019, https://www.latimes .com/local/lanow/la-pol-ca -natural-hair-discrimination-bill -20190703-story.html.

THE ANNIE HALL

Hiltz, Steph. "Annie Hall, reluctant style icon." *Boston Globe,* July 31, 2013, https://www.bostonglobe. com/lifestyle/style/2013/07/31 /annie-hall-reluctant-style-icon /J1HB7STJwEtVIQodEXcaWI/story .html%20.

Malmed, Alexandra. "How to Steal Annie Hall's L.A. Look." *Los Angeles Magazine,* June 26, 2015, https://www.lamag.com /theclutch/annie-hall-in-l-a/.

Pîrvu, Ada. "Diane Keaton: The Real Look Behind Annie Hall." *Classiq,* Feb. 2, 2018, https://classiq.me /diane-keaton-the-real-look -behind-annie-hall.

Tindle, Hannah. "Annie Hall's Lessons in Self-Directed Style." *AnOther Magazine,* Nov. 23, 2016, http://www.anothermag.com /fashion-beauty/9310/annie-halls -lessons-in-self-directed-style.

Walker, Zoe. "Annie Hall is 40! Style Lessons to Learn from the Woody Allen Classic." *Viva,* April 21, 2017, https://www.viva.co.nz/article /fashion/woody-allen-diane -keaton-annie-hall-40th -anniversary/.

THE BANANA SKIRT

Baker, Jean-Claude, and Chris Chase. *Josephine: The Hungry Heart.* New York: Random House, 1993.

Crosley, Sloane. "Exploring the France That Josephine Baker Loved." *New York Times,* July 12, 2016, https://www.nytimes.com /2016/07/17/travel/josephine -baker-paris-france.html.

Hammond, Bryan, and Patrick O'Connor. *Josephine Baker.* London: Jonathan Cape, 1998.

Jerkins, Morgan. "90 Years Later, the Radical Power of Josephine Baker's Banana Skirt." *Vogue,* June 3, 2016, https://www.vogue.com /article/josephine-baker-90th -anniversary-banana-skirt.

Papich, Stephen. *Remembering Josephine.* Indianapolis: Bobbs-Merrill, 1976.

Sowinska, Alicja. "Dialectics of the Banana Skirt: The Ambiguities of Josephine Baker's Self-Representation." Ann Arbor, MI: MPublishing. Fall 2005–Spring 2006.

THE BIKINI

Foreman, Katya. "Culture—Why the Bikini Became a Fashion Classic." *BBC News,* Oct. 21, 2014, www.bbc .com/culture/story/20130913 -the-bikini-an-itsy-bitsy-classic.

Monet, Dolores. "Swimsuit—the History of Swimwear for Women." *Bellatory*, Aug. 1, 2017, bellatory.com/clothing/SwimsuitHistoryofSwimwearforWomen.

Walsh, G. P. "Kellermann, Annette Marie (1886–1975)." *Australian Dictionary of Biography*, 1983, http://adb.anu.edu.au/biography/kellermann-annette-marie-6911

THE BLACK BERET
Bateman, Kristen. "The Political History of the Beret." *L'Officiel*, Dec. 27, 2017, https://www.lofficielusa.com/fashion/the-political-history-of-the-beret.

King, Jamilah. "The Important Message Behind Beyoncé's Dancers' Outfits Capped Off Her Most Important Week." *Mic*, Feb. 7, 2016, https://www.mic.com/articles/134594/the-important-message-behind-beyonces-dancers-outfits-capped-off-her-most-important-week#.c38QlSrqW

Lubitz, Rachel. "The History of the Beret: How a Peasant's Hat Turned into a Political Statement." *Mic*, June 21, 2016, https://www.mic.com/articles/146546/the-history-of-the-beret-how-a-peasants-hat-turned-into-a-political-statement.

Patton, Phil. "Noticed; Some Ex-G.I.'s Say Berets Are Not for General Issue." *New York Times*, Mar. 11, 2001, https://www.nytimes.com/2001/03/11/style/noticed-some-ex-gis-say-berets-are-not-for-general-issue.html.

Wiseman, Eva. "Hats off: why the beret is back on the frontline of fashion." *Guardian*, Sep. 12, 2017, https://www.theguardian.com/fashion/2017/sep/12/hats-off-why-the-beret-is-back-on-the-frontline-of-fashion.

Zavareh, Houman. "How the Black Panthers Influenced Today's Music & Fashion." *Highsnobiety*, Mar. 2, 2016, https://www.highsnobiety.com/2016/03/02/black-panther-party-influence-music-fashion/.

THE BLOOMER
Boissoneault, Lorraine. "Amelia Bloomer Didn't Mean to Start a Fashion Revolution, But Her Name Became Synonymous With Trousers." *Smithsonian.com*, Smithsonian Institution, May 24, 2018, www.smithsonianmag.com/history/amelia-bloomer-didnt-mean-start-fashion-revolution-her-name-became-synonymous-trousers-180969164/.

Smith, Catherine, and Cynthia Grieg. *Women in Pants: Manly Maidens, Cowgirls, and Other Renegades*. New York: Abrams, 2003.

Steckler, Molly, et al. "From Bloomers to Pantsuits: A Brief History of Women's Dress Reform." *Saturday Evening Post*, Feb. 12, 2018, www.saturdayeveningpost.com/2018/02/bloomers-pantsuits-brief-history-womens-dress-reform/.

THE BOB
Dyett, Linda. "Bye to 'Real Housewife' Hair." *New York Times*, Jan. 8, 2019, www.nytimes.com/2019/01/08/style/should-i-cut-my-hair.html.

Spivack, Emily. "The History of the Flapper, Part 4: Emboldened by the Bob." *Smithsonian.com*, Feb. 26, 2013, www.smithsonianmag.com/arts-culture/the-history-of-the-flapper-part-4-emboldened-by-the-bob-27361862/.

THE BREAST PUMP
Gonzales, Erica. "Rachel McAdams Wears a Breast Pump and Versace in a Badass Photo Shoot." *Harper's Bazaar*, Dec. 20, 2018, https://www.harpersbazaar.com/celebrity/latest/a25631334/rachel-mcadams-breast-pump-photo-shoot/.

Rhue, Holly. "Rachel McAdams Wears Versace, Diamonds, and a Breast Pump for New Magazine Cover Shoot." *Elle*, Dec. 19, 2018, https://www.elle.com/culture/celebrities/a25628292/rachel-mcadams-breastpump-magazine-cover/.

Ali, Rasha. "New mom Rachel McAdams looks fierce with breast pump in a magazine shoot photo." *USA Today*, Dec. 19, 2018, https://www.usatoday.com/story/life/allthemoms/2018/12/19/rachel-mcadams-fiercely-wears-breast-pump-magazine-shoot/2360985002/.

THE CAPE
Bromwich, Jonah Engel, and Valeriya Safronova. "At Met Gala, Rihanna and Lena Waithe Dress for a Future-Era Church." *New York Times*, May 7, 2018, https://www.nytimes.com/2018/05/07/style/met-gala.html.

Okwodu, Janelle. "'I Felt Like a Gay Goddess': Lena Waithe on Her Epic Met Gala Pride Cape." *Vogue*, May 8, 2018, https://www.vogue.com/article/lena-waithe-pride-cape-met-gala-story-behind.

Rich, Katey. "Met Gala: Lena Waithe Wears a Rainbow Pride-Flag Cape." *Vanity Fair*, May 7, 2018, https://www.vanityfair.com/style/2018/05/lena-waithe-met-gala-cape.

Yohannes, Alamin. "Lena Waithe makes powerful statement at Met Gala with rainbow cape." *NBC News*, May 8, 2018, https://www.nbcnews.com/feature/nbc-out/lena-waithe-makes-powerful-statement-met-gala-rainbow-cape-n872371.

THE CAPRIS
Desta, Yohana. "How Mary Tyler Moore Subverted TV Sexism with a Pair of Capris." *Vanity Fair*, Jan. 25, 2017. https://www.vanityfair.com

/hollywood/2017/01/mary-tyler
-moore-pants.

Gross, Terry. Interview with Mary
Tyler Moore. NPR *Fresh Air*, 1995.
https://www.npr.org/2016/12/09
/504960137/remembering-grant
-tinker-mary-tyler-moore-producer
-and-nbc-chair.

Komar, Marlen. "Why Mary Tyler
Moore's Capri Pants May Have Been
The Most Important Costume on
TV." *Bustle*, Jan. 25, 2017. https
://www.bustle.com/p/why-mary
-tyler-moores-capri-pants-may
-have-been-the-most-important
-costume-on-tv-33131.

Murphy, Mary Jo. "Sex and That
'70s Single Woman, Mary Tyler
Moore." *New York Times*, Jan. 25,
2017. https://www.nytimes.com
/2017/01/25/arts/television/mary
-tyler-moore-show-moments.html.

THE CHEONGSAM
Gao, Sally. "A Brief History of the
Cheongsam." *Culture Trip*, Dec. 9,
2016, https://theculturetrip.com
/asia/china/articles/a-brief-history
-of-the-cheongsam/.

Jansen, Chiu-Ti. "In the Mood for
Cheongsam: New Women in Old
Shanghai Glamour at MoCA."
Sotheby's, May 1, 2013, https://www
.sothebys.com/en/articles/in-the
-mood-for-cheongsam-new
-women-in-old-shanghai-glamour
-at-moca.

Lau, Joyce. "History of a Dress,
Chinese Style." *New York Times*,
Aug. 30, 2010, https://www
.nytimes.com/2010/08/31
/fashion/31iht-FDRESS.html.

Paridon, Elsbeth Van. "The Cheon-
gsam as a Cultural Revolutionary."
Temper Magazine, June 20, 2017,
https://temper-magazine.com
/china/the-cheongsam-as-a
-cultural-revolutionary-starring
-chic-xique-ii.

Wong, Hiufu. "Sexy, skintight,
sophisticated: How China's iconic

dress has survived a century."
CNN, June 30, 2015, http://edition
.cnn.com/style/article/cheongsam
-exhibition-hk/index.html.

THE CONE BRA
Campbell, Jennifer. "Jean Paul
Gaultier Moment: Madonna's
Cone Bra." *Flare*, Jun. 6, 2011,
https://www.flare.com/fashion
/jean-paul-gaultier-moment
-madonnas-cone-bra/.

Garber, Megan. "The First Bra Was
Made of Handkerchiefs."
Atlantic, Nov. 3, 2014, https://www
.theatlantic.com/technology
/archive/2014/11/the-first-bra-was
-made-of-handkerchiefs/382283/.

Steele, Valerie. "The Hard Body:
A Muscular Corset." *The Corset:
A Cultural History.* New Haven &
London: Yale University Press, 2001.

Terrero, Nina. "Madonna's
Cone Bra turns 25: How this
Gaultier lingerie's legacy lingers."
Entertainment Weekly, Aug. 13,
2015, https://ew.com/gallery
/madonna-cone-bra-anniversary/.

THE CROP TOP
Bucci, Jessica. "Fashion Archives:
A Look at the History of the Crop
Top." *Startup Fashion*, Nov. 7, 2015,
https://startupfashion.com
/fashion-archives-history-crop-top/.

Denomme, Jessica. "The History
Of: The Crop Top." *Toronto Standard*,
Aug. 2, 2012, http://www
.torontostandard.com/style
/the-history-of-the-crop-top/.

MeTV Staff. "Bellies have a bizarre
history on the small screen." *MeTV*,
May 11, 2017, https://www.metv.com
/lists/navel-gazing-the-first-female
-belly-buttons-ever-seen-on-tv.

Sessions, Debbie, and Oscar
Sessions. "1940s Blouses, Shirts
and Tops Fashion History."
Vintage Dancer, Feb. 20, 2014,
https://vintagedancer.com
/1940s/1940s-blouses-shirts-tops/.

THE DAISY DUKES
Castiglio, Daniel. "A Short(s) Story:
An Abbreviated History of Daisy
Dukes." *Rebel Circus*, Apr. 27, 2015,
https://www.rebelcircus.com
/blog/shorts-story-abbreviated
-history-daisy-dukes/.

Newell-Hanson, Alice. "A Brief
History of Denim Cutoffs, From
Daisy Duke to Debbie Harry." *Vice*,
June 13, 2016, https://i-d.vice.com
/en_us/article/59bv5b/a-brief
-history-of-denim-cutoffs-from
-daisy-duke-to-debbie-harry.

THE DISSENT COLLAR
Barnes, Robert. "Justices Have
Differing Views of Order in
the Court." *Washington Post*,
Sept. 4, 2009, http://www
.washingtonpost.com/wp-dyn
/content/article/2009/09/03
/AR2009090303790.html.

Couric, Katie. "Justice Ginsburg
Exhibits Her Famous Collar
Collection." *Yahoo News Videos*,
July 31, 2014, https://www.yahoo
.com/news/video/justice-ginsburg
-exhibits-her-famous-194517521
.html.

Foussianes, Chloe. "Ruth Bader
Ginsburg's Collars Decoded: What
Each Neckpiece Means." *Town &
Country Magazine*, Nov. 30, 2018,
https://www.townandcountrymag
.com/society/politics/a25362496
/ruth-bader-ginsburg-collar
-meaning/.

Garelick, Rhonda. "The soft power
impact of Ruth Bader Ginsburg's
decorative collars." *CNN*, Aug. 20,
2018, https://www.cnn.com/style
/article/ruth-bader-ginsburg-collars
/index.html.

George, Kavitha. "What Do Ruth
Bader Ginsburg's Collars Mean?
Each One Has A Special Story."
Bustle, June 5, 2018, https://www.
bustle.com/p/what-do-ruth
-bader-ginsburgs-collars-mean
-each-one-has-a-special-story
-9288551.

O'Connor, Sandra Day. "Justice Sandra Day O'Connor on Why Judges Wear Black Robes." *Smithsonian Magazine*, November 2013, https://www.smithsonianmag.com/history/justice-sandra-day-oconnor-on-why-judges-wear-black-robes-4370574/.

THE DURAG

Acquaye, Alisha. "The Renaissance of the Durag." *Allure*, Dec. 26, 2018, https://www.allure.com/story/durag-fashion-history-black-people-reclaiming-the-narrative.

Charlton, Lauretta. "John Edmonds's Luminous Images of Men in Do-rags." *New Yorker*, Mar. 18, 2017, https://www.newyorker.com/culture/photo-booth/john-edmondss-luminous-images-of-men-in-do-rags.

Garcia, Sandra E. "The Durag, Explained." *New York Times*, May 14, 2018, https://www.nytimes.com/2018/05/14/style/durag-solange-met-gala.html.

Josephs, Brian. "Who Criminalized the Durag?" *GQ*, Mar. 2, 2017, https://www.gq.com/story/who-criminalized-the-durag.

Nasheed, Jameelah. "When Black Women Were Required By Law to Cover Their Hair." *Vice*, Apr. 10, 2018, https://www.vice.com/en_us/article/j5abvx/black-womens-hair-illegal-tignon-laws-new-orleans-louisiana.

White, Brooklyn. "Why the symbolism behind Solange's durag at the 2018 Met Gala matters." *HelloGiggles*, May 8, 2018, https://hellogiggles.com/awards-events/red-carpet/met-gala/symbolism-solange-durag-2018-met-gala/.

THE FIRE COAT

Brown, Lillian. "Nancy Pelosi and 'Big Coat Energy.'" *Boston Globe*, Dec. 13, 2018. https://www.bostonglobe.com/lifestyle/names/2018/12/12/nancy-pelosi-and-big-coat-energy/oaNJooERi8xKV8mOgEJCDM/story.html.

Colón, Ana. "Nancy Pelosi's Red Coat Was Such a Moment It's Coming Back to Stores in 2019." *Glamour*, Dec. 12, 2018. https://www.glamour.com/story/nancy-pelosi-red-coat-max-mara.

Friedman, Vanessa. "Nancy Pelosi's Coat Catches Fire." *New York Times*, Dec. 12, 2018. https://www.nytimes.com/2018/12/12/fashion/nancy-pelosi-coat.html.

Lawler, Ophelia Garcia. "Here's Why Everyone Is Talking About Nancy Pelosi's Coat." *The Cut*, *New York Magazine*, Dec. 12, 2018, https://www.thecut.com/2018/12/nancy-pelosis-coat-takes-over-the-internet.html.

Truong, Kimberly. "Barry Jenkins Really Loves Nancy Pelosi's Coat." *The Cut*, *New York Magazine*, Dec. 12, 2018, https://www.thecut.com/2018/12/barry-jenkins-tweets-about-nancy-pelosi-red-coat.html.

THE FLAPPER DRESS

Cellania, Miss. "The Rise of the Flapper." *Mental Floss*, Aug. 25, 2009, http://mentalfloss.com/article/22604/rise-flapper.

Spivack, Emily. "The History of the Flapper, Part 1: A Call for Freedom." *Smithsonian.com*, Feb. 5, 2013, https://www.smithsonianmag.com/arts-culture/the-history-of-the-flapper-part-1-a-call-for-freedom-11957978/.

Spivack, Emily. "The History of the Flapper, Part 3: The Rectangular Silhouette." *Smithsonian.com*, Feb. 19, 2013, https://www.smithsonianmag.com/arts-culture/the-history-of-the-flapper-part-3-the-rectangular-silhouette-20328818/.

Spivack, Emily. "The History of the Flapper, Part 5: Who Was Behind the Fashions?" *Smithsonian.com*, April 5, 2013, https://www.smithsonianmag.com/arts-culture/the-history-of-the-flapper-part-5-who-was-behind-the-fashions-20996134/.

THE FLOWER CROWN

Belair, Lauriane. "A Brief History of Flower Crowns: From Antiquity to Queen B." *Fashion Magazine*, Aug. 7, 2018, https://fashionmagazine.com/fashion/flower-crowns-beyonce/.

"Marsha P. Johnson Biography." *Biography.com*, A&E Television Networks, Apr. 15, 2019, https://www.biography.com/activist/marsha-p-johnson.

Borrelli-Persson, Laird. "The Best Flower Crowns of All Time, from Frida Kahlo to Jennifer Lawrence." *Vogue*, Jun. 22, 2018, https://www.vogue.com/article/flower-crowns-hair-frida-kahlo-kate-moss.

Chan, Sewell. "Overlooked—Marsha P. Johnson." *New York Times*, Mar. 8, 2018, https://www.nytimes.com/interactive/2018/obituaries/overlooked-marsha-p-johnson.html.

Florio, Angelica. "Meet Marsha P. Johnson, an iconic LGBTQ rights leader who's sure to inspire you." *HelloGiggles*, Jun. 11, 2018, https://hellogiggles.com/lifestyle/marsha-p-johnson-lgbtq-rights-leader/.

Ryan, Hugh. "Power to the People: Exploring Marsha P. Johnson's Queer Liberation." *Out*, Aug. 24, 2017, https://www.out.com/out-exclusives/2017/8/24/power-people-exploring-marsha-p-johnsons-queer-liberation.

THE GAULLE

London, Caroline. "The Marie Antoinette Dress That Ignited the Slave Trade." *Racked*, Jan. 10, 2018, https://www.racked

.com/2018/1/10/16854076
/marie-antoinette-dress-slave
-trade-chemise-a-la-reine.

Weber, Caroline. *Queen of Fashion:
What Marie Antoinette Wore to
the Revolution.* New York: Henry
Holt, 2006.

THE HOT PANTS
Cohn, Gretta. "Hot Pants: A Short,
Happy and Musical Career."
Soundcheck, New York Public Radio,
Aug. 19, 2012.

Moore, Jennifer Grayer. *Fashion
Fads through American History:
Fitting Clothes into Context.* Santa
Barbara, CA: Greenwood, 2016:
68–71.

Spivack, Emily. "Hit-Making Hot
Pants." *Smithsonian*, Aug. 24, 2012,
https://www.smithsonianmag
.com/arts-culture/hit-making-hot
-pants-32135488/.

"Hot Pants: A short but happy
career." *Life*, December 31, 2017:
14–15. Print.

Willans, Joel. "History's coolest fads:
No. 1–Hot Pants." *Whizzpast*, Oct. 26,
2013, http://www.whizzpast
.com/hot-pants/.

THE JEANS
"An Arizona Episode."
Cosmopolitan, 27: 673677.
May-October 1899.

Diep, Francie. "The Long History
of Jeans in Women's Protest."
PacificStandard, Jun. 14, 2017,
https://psmag.com/social-justice
/history-jeans-womens-protest.

Idacavage, Sara. "Fashion History
Lesson: The Bond Between Ladies
and Levi's." *Fashionista*, Mar. 3, 2017,
https://fashionista.com/2017/03
/levis-jeans-womens-denim-history.

Montanez, Marlene. "The History
of Jeans." *Live About*, Jan. 2, 2019,
https://www.liveabout.com/the
-history-of-jeans-2040397.

Stanley, Alessandra. "Ruling on
Tight Jeans and Rape Sets Off
Anger in Italy." *New York Times*, Feb.
16, 1999, https://www.nytimes
.com/1999/02/16/world/ruling-on
-tight-jeans-and-rape-sets-off
-anger-in-italy.html.

THE JUMPSUIT
Brownlees, Jenny. "Diana Ross Circa
1970 Is Very on Trend for Right
Now." *Who What Wear*, Dec. 22,
2018, https://www.whowhatwear
.com/diana-ross-style.

Bucci, Jessica. "Fashion Archives:
A Look at the History of the
Jumpsuit." *Startup Fashion*, Oct. 29,
2016, https://startupfashion.com
/fashion-archives-a-look-at-the
-history-of-the-jumpsuit/.

Radke, Heather. "The Jumpsuit That
Will Replace All Clothes Forever."
Paris Review, Mar. 21, 2018, https://
www.theparisreview.org
/blog/2018/03/21/the-jumpsuit
-that-will-replace-all-clothes
-forever/.

Penny, Daniel. "A Brief History of
the Jumpsuit." *Grailed*, Mar. 21,
2018, https://www.grailed.com
/drycleanonly/jumpsuit-boilersuit
-history.

Scappini, Alessandra. "Biography of
Thayaht." *THAYAHT & RAM Archive*,
http://www.thayaht-ram.com/wp
/thayaht/bio-thayaht/.

Vartan, Kristin. "Diana Ross's Most
Major Fashion Moments Ever." *E!
News*, Nov. 18, 2017, https://www
.eonline.com/news/894731
/diana-ross-most-major-fashion
-moments-ever.

Whetsell, Tripp. "30-year
anniversary of the night Diana
Ross reigned as it rained in Central
Park." *New York Daily News*, Jul. 21,
2013, .https://www.nydailynews
.com/entertainment/music-arts
/diana-ross-rained-central-park
-article-1.1404781

THE LOBSTER DRESS
Hargrove, Channing. "Elsa
Schiaparelli & Salvador Dalí,
Together Again." *Refinery29*, Oct. 26,
2017, https://www.refinery29.com
/en-us/2017/10/178307/elsa
-schiaparelli-dali-museum
-review-2017.

Spencer, Hayley. "Schiaparelli
recreate Wallis Simpson's famously
provocative lobster dress in
new Haute Couture collection."
Telegraph, Jan. 23, 2017, https
://www.telegraph.co.uk/fashion
/brands/schiaparelli-have-recreated
-wallis-simpsons-famously
-provocative/.

THE MARATHONER
Adams, Char. "Runner Defends
Letting Period Bleed Freely at
London Marathon: 'Women's
Bodies Don't Exist for Public
Consumption'." *People*, Aug 13, 2015,
https://people.com/celebrity
/kiran-gandhi-period-runner
-speaks-out-against-critics/.

Gandhi, Kiran. "Going With the
Flow." *Medium*, July 20, 2015,
https://medium.com/endless
/going-with-the-flow-blood
-sisterhood-at-the-london
-marathon-f719b98713e7.

Hanafy, Erin. "Kiran Gandhi–the
Menstrual Badass of the London
Marathon–Speaks Out." *Well and
Good*, Sept. 30, 2016, https://www
.wellandgood.com/good-advice
/kiran-gandhi-london-marathon
-period/slide/2/.

McGraa, Taylor. "Why I ran for
26 miles on my period." *Dazed*,
Aug. 13, 2015, http://www
.dazeddigital.com/artsandculture
/article/25908/1/why-i-ran-for-26
-miles-on-my-period.

THE MEAT DRESS
Fry, Stephen. "Lady Gaga interview:
the full transcript." *Financial Times*,
May 27, 2011. https://www.ft.com

/content/aa5b5ec4-86c8-11e0-9d41
-00144feabdco.

Gaga, Lady. "Lady Gaga's 'Don't
Ask, Don't Tell' Speech: The Full
Transcript." *MTV*, Sept. 20, 2010,
http://www.mtv.com/news
/1648304/lady-gagas-dont
-ask-dont-tell-speech-the-full
-transcript/.

Keirans, Maeve. "See What Lady
Gaga's Meat Dress Looks Like
Now—5 Years Later." *MTV*, Aug. 28,
2015, http://www.mtv.com/news
/2254239/lady-gaga-meat-dress
-vmas/.

Johnson, Ted. "Lady Gaga's DADT
Speech: 'The Prime Rib of America.'"
Variety, Sept. 20, 2010, https
://variety.com/2010/biz/opinion
/lady-gagas-dadt-speech-the
-prime-rib-of-america-38764/.

THE MINISKIRT

Bourne, Leah. "A History of the
Miniskirt: How Fashion's Most
Daring Hemline Came To Be."
StyleCaster, StyleCaster, Nov. 28,
2018, stylecaster.com/history
-of-the-miniskirt/.

Harthorne, Michael. "Kansas
Senator to 'Ladies': No Mini-Skirts,
Please." *USA Today*, Gannett
Satellite Information Network,
Jan. 23, 2016, www.usatoday.com
/story/news/nation-now/2016/01
/23/kansas-senator-ladies-no
-mini-skirts-please/79223156/.

Foreman, Katya. "Short but Sweet:
The Miniskirt." *BBC News*, Culture,
Oct. 21, 2014, www.bbc.com
/culture/story/20140523-short
-but-sweet-the-miniskirt.

Lubitz, Rachel. "The Unabashedly
Feminist History of the Miniskirt."
Mic, Mic Network Inc., May 23, 2017,
mic.com/articles/139429/power
-clothes-the-unabashedly-feminist
-history-of-the-miniskirt#.s6VJ2IdUr.

"How Mary Quant's Mini-Skirt
Conquered the World."

Nydailynews.com, New York
Daily News, Jan. 10, 2019, www.
nydailynews
.com/life-style/fashion/mary
-quant-mini-skirt-conquered
-world-article-1.1608236.

Petrarca, Emilia. "From Twiggy
to Paris Hilton to Bella Hadid,
Miniskirts Are Back In Fashion
Once Again." *W Magazine*, July 7,
2017, www.wmagazine.com
/story/miniskirts-womens
-liberation-trend.

THE NAKED DRESS

Marie Claire. "The History Of The
Naked Dress." *Marie Claire*, Dec. 17,
2015, www.marieclaire.co.uk
/fashion/the-history-of-the
-naked-dress-235273.

Nguyen, Diana. "Hollywood &
the Naked Dress: A Love Story." *E!
Online*, E! News, July 28, 2015, www
.eonline.com/news/680644/sheer
-perfection-a-brief-history-of-the
-naked-dress-on-the-red-carpet.

Schreiber, Sarah. "The Most
Scandalous Naked Dresses in
History." *Good Housekeeping*, May
11, 2018, www.goodhousekeeping
.com/beauty/fashion/g4436
/history-naked-dresses/?slide=2.

THE OLYMPIC HIJAB

Deb, Sopan. "Ibtihaj Muhammad:
The Olympic Fencer Is Charting
Her Own Path." *New York Times*,
July 14, 2018, https://www
.nytimes.com/2018/07/24/books
/ibtihaj-muhammad-fencing-hijab
-olympics.html.

Hall, Matthew. "Ibtihaj Muham-
mad: 'Being made to feel different
is what makes it all the more
difficult.'" *Guardian*, July 27, 2018,
https://www.theguardian
.com/sport/2018/jul/27/ibtihaj
-muhammad-fencing-hijab
-olympics.

Kaplan, Sarah. "Meet Ibtihaj
Muhammad, the history-making

Olympian who called out SXSW
for telling her to remove her hijab."
Washington Post, March 14, 2016,
https://www.washingtonpost.com
/news/morning-mix/wp/2016
/03/14/meet-ibtihaj-muhammad
-the-history-making-olympian
-who-called-out-sxsw-for-telling
-her-to-remove-her-hijab/?utm
_term=.88ea676af41e.

McGuire, David. "Ibtihaj
Muhammad: A Journey Bigger
than Me." *Heart and Soul*, BBC
News Aug. 19, 2018.

THE PACHUCA

Escobedo, Elizabeth R. From
*Coveralls to Zoot Suits: The Lives
of Mexican American Women
on the World War II Home Front*.
University of North Carolina Press,
2013.

Fayette, William C. "Zoot Suiters
Run for Cover but Their 'Cholitas'
Carry On." *Washington Daily News*,
June 11, 1943.

Machado, Carmen Maria. "A New
Generation is Taking on L.A.'s Latinx
Beauty Rituals." *Vogue*, Feb. 13, 2019,
https://www.vogue.com/article
/latinx-beauty-march-2019-issue.

Pappous, Christina. "La Pachuca:
Women in Zoot Suits" *States of
Incarceration*, https://statesof
incarceration.org/story/la-pachuca
-women-zoot-suits.

Ramirez, Catherine. *The Woman in
the Zoot Suit: Gender, Nationalism,
and the Cultural Politics of Memory*
Durham, NC: Duke University
Press, 2009.

THE PANTS

Bianco, Marcie, and Merryn
Johns. "The Most Daring Thing
About Katharine Hepburn? Her
Pants." *Vanity Fair*, May 12, 2016,
https://www.vanityfair.com
/hollywood/2016/05/katharine
-hepburn-style-pants.

Cooper, Kathleen. "Wearing the Pants: A Brief Western History of Pants." *The Toast*, Aug. 7, 2014, http://the-toast.net/2014/08/07 /wearing-pants-brief-history/.

Hamdi, Yemina. "Sudanese women can still be whipped for wearing pants." *Arab Weekly*, Oct. 28, 2018, https://thearabweekly.com /sudanese-women-can-still -be-whipped-wearing-pants.

Harrison, Scott. "In 1938, L.A. woman went to jail for wearing slacks in courtroom." *Los Angeles Times*, Oct. 23, 2014, https://www .latimes.com/local/california /la-me-california-retrospective -20141023-story.html.

Mackenzie-Smith, Stevie. "Wide Trousers and Eye Rolls: Saluting Katharine Hepburn." *AnOther Magazine*, June 28, 2017, https://www.anothermag.com /fashion-beauty/9965/wide -trousers-and-eye-rolls-saluting -katharine-hepburn.

Mondalek, Alexandra. "The History of Women Wearing Pants As Power Symbol." *Huffington Post,* March 2, 2018, https://www.huffpost.com /entry/the-history-of-women -wearing-pants-as-power-symbol _n_5a99bb95e4b0a0ba4ad34fe7.

THE PASTY
Gamble, Ione. "Remember When Lil' Kim Wore A Pasty To The 1999 VMAs? The Moment Is Unfor- gettable." *Bustle*, Aug. 24, 2016, https://www.bustle.com/articles /180362-remember-when-lil-kim -wore-a-pastie-to-the-1999-vmas -the-moment-is-unforgettable.

hooks, bell. "Hardcore Honey: bell hooks Goes on the Down Low with Lil' Kim." *Paper,* May 1997, accessed online http://www .papermag.com/lil-kim-bell-hooks1 -1427357106.html.

Lawrence, Kelsey. "Lil' Kim's Most Iconic Outfits, In Honor Of Her New

Album." *Cools*, Apr. 1, 2019, https ://cools.com/lil-kim-iconic-outfits.

Oliver, Dana. "Lil' Kim's Purple Pasty Moment At The MTV Video Music Awards Is Unforgettable." *Huffington Post*, Jul. 11, 2013, https://www.huffpost.com /entry/lil-kim-purple-pasty -photos_n_3574366.

Porter, Nia. "Revisiting the Style of Hip-Hop's Fashion Icon Lil' Kim." *Racked*, Mar. 3, 2016, https://www .racked.com/2016/3/3/11151790/lil -kim-style.

Steinfeld, Sara. "How Nipple Pasties Evolved From Circus Staple to Coachella Chic." *Allure*, May 11, 2016, https://www.allure.com /story/history-of-nipple-pasties.

THE PINK PUSSYHAT
"The Pussyhat Story." *PUSSYHAT PROJECT*, https://www.pussyhat project.com/our-story/.

Draucculieri, Julia. "The Pussyhat Project's Krista Suh Reflects On The Hat's Powerful Impact." *Huffington Post*, Jan. 18, 2019, https://www.huffpost.com/entry /pussyhat-project-krista-suh _n_5c424135e4b027c3bbc1b7a3.

Compton, Julie. "Pink 'Pussyhat' Creator Addresses Criticism Over Name." *NBC News*, Feb. 7, 2017, https://www.nbcnews.com /feature/nbc-out/pink-pussyhat -creator-addresses-criticism -over-name-n717886.

Darrough, Celia. "What Do The Pink Hats Mean? The Women's March & The Pussyhat Project Have A Purposeful Message." *Bustle*, Jan. 21, 2017, https://www.bustle.com/p /what-do-the-pink-hats-mean -the-womens-march-the-pussyhat -project-have-a-purposeful -message-32088.

Oringel, Amy. "The Secret Jewish History Of The Pussyhat." *Forward*, Mar. 7, 2017, https://forward.com

/culture/365099/the-secret -jewish-history-of-the-pussyhat/.

Reimel, Erin, and Krystin Arneson. "Here's the Powerful Story Behind the Pussyhats at the Women's March." *Glamour*, Jan. 22, 2017, https://www.glamour.com/story /the-story-behind-the-pussyhats -at-the-womens-march.

THE PIXIE CUT
Barr, Sabrina. "The History of the Pixie Cut Hairstyle." *Independent*, Jan. 14, 2019, https://www .independent.co.uk/life-style /fashion/pixie-cut-hairstyle -history-jesinta-franklin-haircut -emma-watson-audrey-hepburn -a8726491.html.

Bricker, Tierney. "The Real Story Behind Felicity's Infamous Haircut That Caused Death Threats, a Ratings Crash and Changed TV Forever." *E! News*, Sept. 28, 2018, https://www.eonline.com/news /972161/the-real-story-behind -felicitys-infamous-haircut-that -caused-death-threats-a-ratings -crash-and-changed-tv-forever.

Connell, Alle. "Kate Mara and Pixie Judgement: Why Do We Shame Women With Short Hair?" *Stylecaster*, 2015, https://stylecaster .com/beauty/pixie-judgement/.

Cox, Johanna. "Short Hairstyles: Do Haircuts Affect Your Love Life?" *Elle*, Jul. 24, 2009, https://www.elle.com /beauty/hair/tips/a2443/short -hairstyles-do-haircuts-affect-your -love-life-335167/.

Hale, James Loke. "Here's The Real Reason Katy Perry Got That Pixie Cut, According To The Artist Herself." *Bustle*, Aug. 13, 2017, https://www.bustle.com/p/heres -the-real-reason-katy-perry-got -that-pixie-cut-according-to-the -artist-herself-76252.

Han, Christina. "26 of the Best Short Haircuts in History." *The Cut*, April 19, 2013, https://www.thecut

.com/2013/04/26-of-the-best
-short-haircuts-in-history.html.

Penny, Laurie. "Why patriarchy
fears the scissors–for women,
short hair is a political statement."
NewStatesmanAmerica, Jan. 25,
2014, https://www.newstatesman
.com/laurie-penny/2014/01/why
-patriarchy-fears-scissors-women
-short-hair-political-statement.

Jennings, Rebecca. "History of
Pixie Cut Hairstyle Origins."
Racked YouTube, Jan. 27, 2018,
https://wwwyoutube.com
/watch?v=WPjOU73BZOY.

THE PLUNGE DRESS
Moss, Jack. "Five Things You Didn't
Know About JLo's 2000 Green
Versace Dress." *AnOther*, Dec. 3,
2018, https://www.anothermag
.com/fashion-beauty/11350/five
-things-you-didnt-know-about
-jlos-2000-green-versace-dress.

Romeyn, Kathryn. "Seven things we
know about Jennifer Lopez's iconic
Versace dress." *Los Angeles Times*,
Jan. 28, 2018, https://www.latimes
.com/fashion/la-ig-2018-grammys
-jennifer-lopez-dress-20180128
-htmlstory.html.

Schmidt, Eric. "The Tinkerer's
Apprentice." *Project Syndicate*, Jan.
19, 2015, https://www.project
-syndicate.org/commentary
/google-european-commission
-and-disruptive-technological
-change-by-eric-schmidt-2015
-01#yMSC5llY7sHATDCO.99.

THE PRESIDENTIAL
PANTSUIT
Clemente, Deirdre. "A President
in a Pantsuit?" *Conversation*,
The Conversation, Sept. 19, 2018,
theconversation.com/a-president-
in-a-pantsuit-68286.

Clinton, Hillary Rodham. *What
Happened*. New York: Simon &
Schuster, 2017.

Euse, Erica. "The Revolutionary
History of the Pantsuit." *Vice*,
Mar. 21, 2016, www.vice.com/en_us
/article/wd7vey/the-history-of-the
-pantsuit-456.

Harrison, Scott. "In 1938, L.A.
Woman Went to Jail for Wearing
Slacks in Courtroom." *Los Angeles
Times*, Oct. 23, 2014, www.latimes
.com/local/california/la-me
-california-retrospective-20141023
-story.html.

Komar, Marlen. "The Evolution Of
The Female Power Suit." *Bustle*,
Dec. 17, 2018, www.bustle.com
/articles/152069-the-evolution
-of-the-female-power-suit-what
-it-means-photos.

Sullivan, Kate. "The Fascinating
History of Women Wearing Suits."
Allure, May 31, 2017, www.allure
.com/story/women-suits-history.

Wright, Jennifer. "Pantsuits for
Women Were Once Illegal." *Racked*,
Dec. 5, 2016, www.racked.com
/2016/12/5/13778914/pantsuits
-history.

THE REBOZO
Foreman, Liza. "Shining a Spotlight
on Mexico's Iconic Textile–The
Rebozo." *Daily Beast*, June 16, 2014,
https://www.thedailybeast.com
/shining-a-spotlight-on-mexicos
-iconic-textilethe-rebozo.

Spiegel, Frances. "The Rebozo in
Art, Culture, and Fashion: Made
in Mexico." *Decoded Arts*, June 9,
2014, https://decodedarts.com
/the-rebozo-in-art-culture-and
-fashion-made-in-mexico/1467.

Styles, Ruth. "Fashion for
revolutionaries! The incredible
story of how the colorful rebozo
scarf changed the course of
Mexican history." *Daily Mail*, May
28, 2014, https://www
.dailymail.co.uk/femail/article
-2640556/The-incredible-story
-colourful-rebozo-scarf-changed
-course-Mexican-history.html.

THE RED LIPSTICK
Felder, Rachel. *Red Lipstick: An Ode
to a Beauty Icon*. New York: Harper
Design, , 2019.

Nguyen, Janet. "Red Lipsticks and
Gold Hoops: Attitudes toward
Makeup Are Changing at Work."
Marketplace, May 8, 2019. https
://www.marketplace.org/2019
/02/19/aoc-makeup-workplace/.

Robin, Marci. "Why it Matters
That Alexandria Ocasio-Cortez
Wore Hoops to Her Swearing-In
Ceremony." *Allure*, Jan 5, 2019.
https://www.allure.com/story
/alexandria-ocasio-cortez-red
-lipstick-hoops-swearing-in
-sonia-sotomayor-nail-polish.

THE REVENGE DRESS
Ferrise, Jennifer. "A Brief History
of the Revenge Dress." *InStyle.com*,
Jul 17, 2017, www.instyle.com
/fashion/a-brief-history-of-the
-revenge-dress.

Lewis, Ashley. "The True Story
Behind Princess Diana's Revenge
Dress." *Reader's Digest*, Oct. 5, 2018,
https://www.rd.com/culture
/story-princess-dianas-revenge
-dress/.

Wong, Brittany. "The Day
Princess Diana and Her 'Revenge
Dress' Shocked The World."
Huffington Post, June 29, 2018,
https://www.huffpost.com/entry
/princess-diana-revenge-dress
_n_5b3514a2e4b0b5e692f5cf6b.

THE ROLLED STOCKING
Everyday Vintage Life: Garters, Part
2. https://16sparrows.typepad.com
/16sparrows/2010/08/everyday
-vintage-life-garters-part-2.html.

Sessions, Debbie. "1920s Rolled
Stockings & Trendy Tights." *Vintage
Dancer*, https://vintagedancer
.com/1920s/rolled-stockings/.

Spivack, Emily. "Stocking Series,
Part 4: The Rebellious Roll Garters."

Smithsonian.com, Oct. 12, 2012, https://www.smithsonianmag.com/arts-culture/stocking-series-part-4-the-rebellious-roll-garters-71671274/.

Rolled Stockings: The Style of the 1920s, And How They Became So Trendy. https://www.vintag.es/2017/06/rolled-stockings-style-of-1920s-and-how.html.

THE SAFETY PIN DRESS

Blair, Olivia. "Elizabeth Hurley on that Versace dress: 'It really wasn't that big a deal to me at the time'." *Harper's Bazaar*, Jun. 12, 2018, https://www.harpersbazaar.com/uk/celebrities/news/a21092624/elizabeth-hurley-versace-dress-hugh-grant/.

Cohen, Claire. "Liz Hurley's safety pin frock changed how we get dressed." *Telegraph*, Sept. 9, 2014, https://www.telegraph.co.uk/women/womens-life/11084446/Liz-Hurleys-safety-pin-frock-changed-how-we-get-dressed-and-that-includes-Mileys-nipple-pasties.html.

THE SLEEVELESS SHIFT

Dowd, Maureen. "Should Michelle Cover Up?" *New York Times*, Mar. 7, 2009, https://www.nytimes.com/2009/03/08/opinion/08dowd.html?em.

Edmonds, Ron. "Michelle Obama's Right to Bear Arms." *People*, Feb. 27, 2009, https://people.com/style/michelle-obamas-right-to-bare-arms/.

Fuller, Bonnie. "Michelle Obama's Sleevegate: Why Can't America Handle Her Bare Arms?" *Huffington Post*, Dec. 7, 2017, https://www.huffpost.com/entry/michelle-obamas-sleevegat_n_171172.

Jones, Vanessa. "Michelle Obama's bare arms stir controversy." *SF Gate*, Mar. 22, 2009, https://www.sfgate.com/living/article/Michelle-Obamas-bare-arms-stir-controversy-3247209.php.

Noveck, Jocelyn. "Why all the fuss over a first lady's bare arms?" The *San Diego Union-Tribune*, Mar. 24, 2009, https://www.sandiegouniontribune.com/sdut-fea-lifestyles-michelle-obama-sleevegate-032409-2009mar24-story.html.

Shabad, Rebecca. "Are sleeveless dresses 'appropriate attire'? Congress doesn't think so." *CBS News*, July 7, 2017, https://www.cbsnews.com/news/are-sleeveless-dresses-appropriate-attire-congress-doesnt-think-so/.

THE SLIP DRESS

Fox, Imogen. "The big reveal: deconstructing the slip dress." *Guardian*, Mar. 7, 2016, https://www.theguardian.com/fashion/2016/mar/07/the-big-reveal-deconstructing-the-slip-dress.

Jackson, Laura and Ray Seigel. "A Visual History of the Slip Dress Worn by Kate Moss, Sofia Coppola, and More." *Harper's Bazaar*, Aug. 17, 2017, https://www.harpersbazaar.com.au/fashion/history-of-slip-dress-14096.

Mlotek, Haley. "Hide and Seek: Everything You Could Possibly Ever Want to Know About the Slip Dress." *Ssense*, 2019, https://www.ssense.com/en-us/editorial/fashion/hide-and-seek-everything-you-could-possibly-ever-want-to-know-about-the-slip-dress.

THE SWAN DRESS

Calfee, Bailey. "Björk's Swan Dress Was The Ultimate Campy Red Carpet Moment." *Nylon*, May 6, 2019, https://nylon.com/bjork-swan-dress-ode.

Douglas, Joanna. "Valentino Remakes Björk's Infamous Swan Dress. Who's Laughing Now?" *Yahoo!* Entertainment, Jan. 24, 2014, https://www.yahoo.com/entertainment/blogs/fashion/valentino-remakes-bjork-39-infamous-swan-dress-39-191700386.html.

Mitchell, Timothy. "Björk's once-ridiculed swan dress now honored at MoMA." *New York Post*, Mar. 15, 2015, https://nypost.com/2015/03/15/bjorks-once-ridiculed-swan-dress-now-displayed-at-moma/.

THE TENNIS CATSUIT

Desmond-Harris, Jenée. "Despite Decades of Racist and Sexist Attacks, Serena Williams Keeps Winning." *Vox.com*, Vox Media, Jan. 28, 2017, www.vox.com/2017/1/28/14424624/serena-williams-wins-australian-open-venus-record-racist-sexist-attacks.

"French Open Says 'Non!' to Serena's Black Catsuit." *AP News*, Associated Press, Aug. 24, 2018, www.apnews.com/a5acc142672642aba7976d0fd0a9e3b6.

LeSavage, Halie. "Here's the Antiquated Reason Serena Williams Is Called 'Mrs. Williams' at Wimbledon." *Glamour*, July 6, 2018, www.glamour.com/story/wimbledon-female-athletes-names-marital-status-serena-williams.

Nittle, Nadra. "The Unabashed Power of Serena Williams's Style." *Racked*, June 1, 2018, www.racked.com/2018/6/1/17414940/serena-williams-french-open-black-catsuit.

Nittle, Nadra. "The Serena Williams Catsuit Ban Shows That Tennis Can't Get Past Its Elitist Roots." *Vox.com*, Aug. 28, 2018, www.vox.com/2018/8/28/17791518/serena-williams-catsuit-ban-french-open-tennis-racist-sexist-country-club-sport.

THE TRICOLOR STRIPE

Blackman, Cally. "How the Suffragettes Used Fashion to Further the Cause." *Guardian*, Oct. 8, 2015, www.theguardian.com/fashion/2015/oct/08/suffragette-style-movement-embraced-fashion-branding.

THE TUXEDO

Bréthous, Julie. "It's a Man's World: Marlene Dietrich and Her Cross-Dressing Wardrobe." *The Costume Society*, costumesociety.org.uk/blog/post/its-a-mans-world-marlene-dietrich-and-her-cross-dressing-wardrobe.

Detrixhe, John, and Marc Bain. "The Hollywood Icon Who Made the Tuxedo a Unisex Symbol." *Quartz*, Dec. 28, 2017, qz.com/1166338/marlene-dietrich-google-honors-the-movie-star-who-made-tuxedos-unisex/.

Foreman, Katya. "Smoking Hot: The Woman's Tuxedo." *BBC News*, Culture, Oct. 21, 2014, www.bbc.com/culture/story/20140710-smoking-hot-the-womans-tuxedo.

Kinzer, Stephen. "Dietrich Buried in Berlin, and Sentiment Is Mixed." *New York Times*, May 17, 1992, www.nytimes.com/1992/05/17/world/dietrich-buried-in-berlin-and-sentiment-is-mixed.html.

Thorpe, Vanessa. "Still Modern after All These Years … Marlene Dietrich's Ageless Charisma." *Guardian*, Nov. 26, 2017, www.theguardian.com/film/2017/nov/26/marlene-dietrich-androgyny-sexuality-exhibitions.

THE TWEED SUIT

Friedlander, Ruthie. "How Coco Chanel Discovered Her Iconic Tweed." *Elle*, Mar. 18, 2014, https://www.elle.com/fashion/news/a15402/the-story-of-chanels-tweed/.

Stafyeva, Elena. "The success of the Chanel tweed suit." *Vintage Voyage*, Sept. 23, 2014, https://vinvoy.com/blog/Chanel-Tweed-Jacket-Success/.

Vernose, Vienna. "The History of the Chanel Tweed Suit." *CR Fashion Book*, Feb. 28, 2019, https://www.crfashionbook.com/fashion/a26551426/history-of-chanel-tweed-suit/.

THE UNIBROW

"Frida Kahlo Biography." *Biography.com*, A&E Television Networks, Apr. 12, 2019, https://www.biography.com/artist/frida-kahlo.

Brown, Mark. "Frida Kahlo's intimate belongings go on display at the V&A." *Guardian*, Mar. 7, 2018, https://www.theguardian.com/artanddesign/2018/mar/08/frida-kahlo-intimate-belongings-on-show-at-v-and-a.

Farago, Jason. "Frida Kahlo's Home Is Still Unlocking Secrets, 50 Years Later." *New York Times*, Feb. 7, 2019, https://www.nytimes.com/2019/02/07/arts/design/frida-kahlo-review-brooklyn-museum.html.

Komar, Marlen. "How Frida Kahlo's fashions brought Mexican politics to the world stage." *CNN*, June 15, 2018, https://www.cnn.com/style/article/frida-kahlo-mexican-fashion/index.html.

Simmonds, Georgia. "Why Frida Kahlo's Unibrow is Important." *Net-A-Porter*, May 8, 2019, https://www.net-a-porter.com/us/en/porter/article-633ccbb7977517f1/lifestyle/culture/frida-kahlo.

Valenti, Lauren. "What Frida Kahlo Kept Inside Her Makeup Bag." *Vogue*, Feb. 6, 2019, https://www.vogue.com/article/frida-kahlo-unibrow-makeup-revlon-lipstick-blush-beauty-mustache-victoria-and-albert-museum.

THE WRAP DRESS

Cohen, Alex. "Diane von Furstenberg's iconic wrap dress turns 40." *Take Two*, KPCC, Jan. 10, 2014, https://www.scpr.org/programs/take-two/2014/01/10/35474/diane-von-furstenbergs-iconic-wrap-dress-turns-40/.

Marie Claire Staff. "Diane von Furstenberg's Style History In Dresses." *Marie Claire UK*, Aug. 2, 2016, https://www.marieclaire.co.uk/fashion/the-story-of-diane-von-furstenberg-s-most-iconic-dresses-30763.

Walden, Celia. "Diane von Furstenburg: interview." *Telegraph*, April 6, 2011, http://fashion.telegraph.co.uk/news-features/TMG8430291/Diane-von-Furstenberg-interview.html.

Acknowledgments

Thank you so much to the incredible Monika Verma, Deanne Katz, Sarah Billingsley, Claire Gilhuly, Christina Loff, Joyce Lin, Rachel Harrell, Maddie Moe, Dana Spector, everyone at Chronicle Books, and the team at Levine Greenberg Rostan. You all make it so fun to create beautiful things together. Special thanks to Miek Coccia for the gift of a name for this book.

Many thanks to my family and friends who continue to pick me up when things get hard, especially during the roller coaster of making books. I'm especially thankful for my sweet husband, Ryan Shaw, who is always my first reader, editor, pep talker, and everything in between. Thank you for all the ways you encourage my fashion choices.

And finally, thank you so much to you, dear reader, for picking up this book. For sharing my books, loving them, gifting them, and giving them a place in your home and your hearts. I hope this book will continue to make you smile, inspire you, and help you feel a little less alone for many years to come.